IMAGES
of America

SELECTIONS FROM THE
OAKLAND TRIBUNE
ARCHIVES

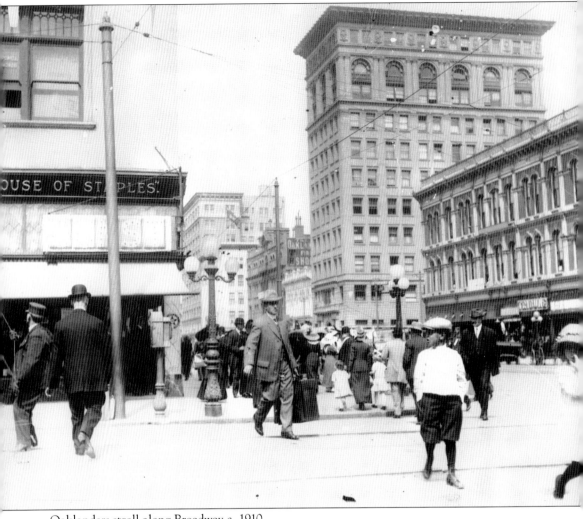

Oaklanders stroll along Broadway *c.* 1910.

ON THE COVER: An army blimp from Moffett Field cruises past the Oakland Tribune Tower in 1937.

IMAGES
of America
SELECTIONS FROM THE
OAKLAND TRIBUNE
ARCHIVES

Annalee Allen

ARCADIA
PUBLISHING

Published by Arcadia Publishing
Charleston SC, Chicago IL, Portsmouth NH, San Francisco CA

Printed in the United States of America

Library of Congress Catalog Card Number: 2006928521

For all general information contact Arcadia Publishing at:
Telephone 843-853-2070
Fax 843-853-0044
E-mail sales@arcadiapublishing.com
For customer service and orders:
Toll-Free 1-888-313-2665

Visit us on the Internet at www.arcadiapublishing.com

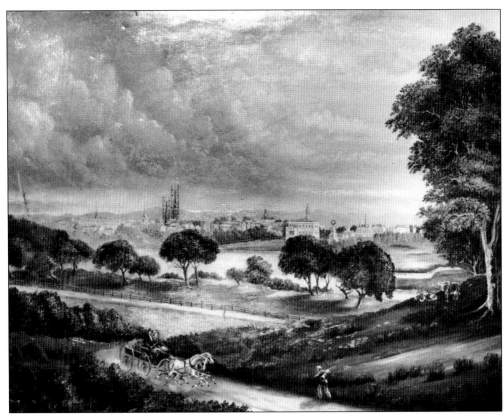

This 1875 painting by L. Trousser, entitled *View of the City*, probably depicts the Oakland skyline in 1874, the year the *Tribune* began publishing. The view shows Adams Point (now Lakeside Park) and the old Academy of the Holy Names Building (right center), which was demolished in the 1950s.

CONTENTS

ACKNOWLEDGMENTS

I would especially like to thank *Tribune* editor Mario Dianda for allowing me to select photographs from the newspaper's collection. To choose only 200 or so images out of a collection so large is quite a task. There are any number of ways one could go about selecting photographs for a book such as this. I decided to focus on some of the landmarks, places, and historical figures that have made Oakland such an incredibly unique city.

For the past nine years, I have been contributing a weekly "landmarks" column to the *Tribune*, and in so doing I have had frequent access to its library clippings and photographic files. In searching for material week after week, I have come across many amazing images, some of which have not been seen for quite a while. I am happy to now be able to share these photographs with a wider audience.

To prepare for this book, I took the time to delve more deeply into the history of the *Tribune* and of the Knowland family. Most would say the Tribune Tower is such an iconic landmark on the Oakland skyline that when the paper was sold in the early 1990s and everyone moved out of the building, it was almost as if the lights went out downtown as well. Many people were affected by the death in 1993 of Robert C. Maynard, the *Tribune's* publisher from 1982 until 1992, a period when the city faced devastating back-to-back disasters: the Loma Prieta earthquake and the 1991 Oakland Hills Fire. As Maynard's *Tribune* covered those terrible events, many saw it as the paper's shining hour.

I believe many Oaklanders like myself felt a psychological lift when new owners of the newspaper decided to move back into the tower. I am also glad that the legacy of Robert Maynard lives on, with the institute that bears his name located in the beautifully situated Preservation Park, near downtown and the tower.

I would also like to thank *Tribune* librarian Marie Dunlap for helping me delve for those hard-to-find topics, hidden in various file folders. Thanks also to Leanne McLaughlin and Kathleen Kirkwood, editors of the Metro section, for their ongoing help and support. Nick Lammers and his staff in the photographic department continue to shoot incredible images every week, adding to a priceless collection that dates back more than 100 years, and I wish to thank them as well.

Thanks finally to my family, especially my parents, who led by example and got me hooked on reading the daily newspaper.

INTRODUCTION

The *Oakland Tribune* newspaper began publishing in 1874 with its first issue appearing on the streets of Oakland on February 21. It sold for 5¢ and soon had a paid circulation of 1,000. Its paper size was 6 by 10 inches, and the first edition contained 4 pages and 43 advertisements. Founding publisher Benet A. Dewes and editor George B. Staniford called their new publication the *Oakland Daily Tribune*. They faced competition from other papers of similar size and composition, also seeking to attract readers of the fledgling East Bay town with a population, at that point, of 10,500. A half decade had passed since Oakland had been selected as the western terminus for the transcontinental railroad, and the town was experiencing rapid growth.

A year later, the paper was acquired by William E. Dargie, a 22-year-old San Francisco native who had previous newspaper experience working for the *San Francisco Evening Bulletin*. Dargie would continue publishing the *Tribune* until his death in 1911, a period of nearly 40 years. During his tenure, Dargie incorporated many publishing innovations such as running news stories from the national wire services and hiring staff photographers. Soon the business moved to larger quarters in the Arlington Building on Ninth Street, in the heart of the growing downtown.

In 1881, Dargie married Erminia Peralta, a great-granddaughter of Don Luis Peralta (1759–1851). Don Luis was the owner of the 44,000-acre San Antonio Rancho, bestowed on him in 1820 by the king of Spain for his years of service in the military. The rancho encompassed what would one day become the cities of Alameda, Albany, Berkeley, and Oakland.

Following her husband's death, Erminia turned to Joseph Knowland, a five-term U.S. congressman who had recently retired from politics, for assistance in operating the newspaper. By paying $228,000 and settling Mrs. Dargie's debts, he gained controlling interest in the paper. Knowland's first editorial as publisher ran on November 3, 1915, stating, "It is perfectly understood that what it (the paper) does, rather than what it promises, will determine the full measure of its worth."

The paper gained significant circulation growth prior to World War I, and in 1918, on the eve of its 44th birthday, Knowland moved the paper to Thirteenth and Franklin Streets into a six-story, reinforced-concrete, Beaux Art–style building that had been erected in 1907 by a San Francisco businessman named Thomas W. Corder. Like many others, Corder had been wiped out by the 1906 earthquake and fire and decided to relocate and start over across the bay. Before Knowland took over, the building previously housed Breuner's Furniture Company.

After Breuner's moved on to a new location "uptown," further up Broadway, Knowland transferred all of the paper's operations into the spacious new headquarters and installed the now-familiar, four-sided, neon-lit clock and a Tribune sign featuring letters 11 feet tall, mounted on steel girders on the building's roof. Next door he added the signature tower, or campanile, five years later. The 20-story, 310-foot medieval Italian-style campanile designed by Edward Faulkes was completed in 1923.

On March 27 of that year, during building construction, famed escape artist Harry Houdini performed a death-defying feat by freeing himself from a straitjacket, suspended from the tower framework, while thousands of spectators watched from the streets below.

During the 1920s, the *Tribune* was instrumental in encouraging many civic reforms in the East Bay, such as establishing the modern version of the Port of Oakland, the East Bay Municipal Utility District, and a regional parks district for Alameda and Contra Costa Counties. Joseph Knowland continued at the helm until 1964, when he passed away at the age of 92. His younger son, William Fife Knowland, who would also have a prominent career in national politics in the 1950s as California's representative in the U.S. Senate, assumed the post of publisher and editor after his father's death.

At its peak, the paper had a daily circulation of over 210,000 readers, and its reach extended beyond Oakland to surrounding cities and suburbs. It had more than 1,000 employees and 3,000 delivery-dealers. Despite the successes, there were also underlying problems due to changing regional demographics, competition, and mounting debts (both personal and corporate) that drove William to commit suicide not long after the paper's centennial celebration in 1974. His son Joseph ran the newspaper for three more years, but in 1977 after 60 years under the ownership of the Knowland family, the *Oakland Tribune* changed hands and was sold to the multimedia corporation Combined Communications.

Robert C. Maynard, an African American journalist and editor from Washington D.C., assumed control of the *Tribune* in 1982, and during his tenure the paper received numerous awards for its extensive coverage of two back-to-back disasters—the 1989 Loma Prieta earthquake and the 1991 Oakland hills fire. The *Tribune* was sold once more upon Maynard's untimely death from cancer at age 56 in 1993.

The new owners, ANG (the Alameda Newspaper Group), relocated the paper's personnel out of the tower complex on Thirteenth Street to a building in Jack London Square. The press equipment was sold, and during the period of transition, it appeared for a time as if the paper's 100-plus-year collection of photographs and news clippings might be sent to the landfill.

Fortunately the Oakland Museum of California stepped in and agreed to take the *Tribune's* photograph files, resulting in a portion of this unique collection of East Bay life and times finding a secure haven there. While many hundreds of images did make their way to the museum on Tenth Street (where they await further cataloging by curatorial staff), just as many, if not more images, stayed behind in file cabinets that were relocated to ANG's new editorial offices in the square. The emptied landmark tower that had so long served as a unique symbol of the Oakland metropolitan area, stood vacant for a time, its future uncertain.

In 1998, the storage cabinets and their contents moved yet again, back to the tower complex on Thirteenth Street (that had been restored by a new owner) when the parent company of the newspaper decided to take up occupancy in its former home. ANG would now occupy the tower complex as renters rather than owners. Nevertheless the move back was seen by many as a hopeful sign of Oakland's long-awaited recovery from Loma Prieta.

The images in this book come from those photographic files, now back in the *Tribune's* sixth-floor newsroom. They represent but a small sample of the work of many dozens of staff photographers who worked for the paper over the years.

Chapter one outlines some of the accomplishments of patriarch Joseph Knowland and other members of his family who guided the *Tribune* and influenced life in Oakland in so many ways. Chapter two illustrates other city builders who impacted not only Oakland, but also California and the world. The area's well-known colleges, universities, and schools are highlighted in chapter three, while the wealth of open space, parks, and gardens are illustrated in chapter four. The lives of "Movers and Shakers," such as Jack London, Gertrude Stein, and architect Julia Morgan are examined in chapter five. Finally landmarks lost and landmarks saved are illustrated in chapter six.

Many, many more images remain on file in the Oakland Tribune's newsroom library—a priceless record of more than 80 years of Bay Area journalism.

One

MR. KNOWLAND'S TRIBUNE

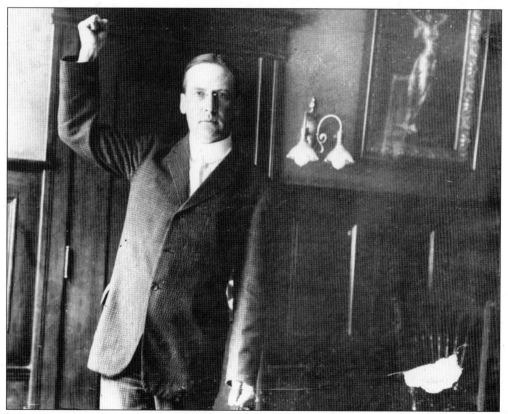

Joseph R. Knowland was born in Alameda in August 1873, a year before the *Oakland Daily Tribune*'s first issue appeared. Knowland's father (also named Joseph) was in the lumber business. J. R., as the son was known, showed an early interest in journalism, starting a school paper at the private Hopkins Academy he attended in Oakland and working in the newsrooms of the *Alameda Argus* and the *Oakland Enquirer* during summer vacations. After graduating from the University of the Pacific, he entered politics at the age of 24, when he was elected to the California State Senate. He was later appointed to serve the unexpired term of U.S. congressman Victor H. Metcalf, which sent him to the nation's capital in 1904.

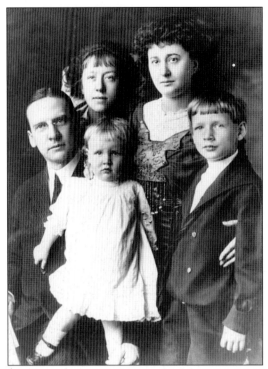

While in college J. R. married Ellie Fife, the daughter of a prominent Tacoma, Washington, family. The couple had a daughter and two sons, however Ellie died very soon after third child William was born in 1908. A year later, J. R. married second wife Emelyn West, pictured in this family portrait. Also pictured here is daughter Emelyn and sons Russ and William (the youngest). Congressman Knowland, a lifelong Republican, was still representing his district in Washington. He was reelected four more times.

This is the family home in Alameda where J. R. grew up. It was built in 1870 with materials shipped around Cape Horn and was located at 2425 Lincoln Avenue. While in Congress, Knowland took particular interest in the construction of the Panama Canal and was able to obtain several million dollars for improvements to the Oakland Harbor and the estuary channel that separated Oakland from Alameda.

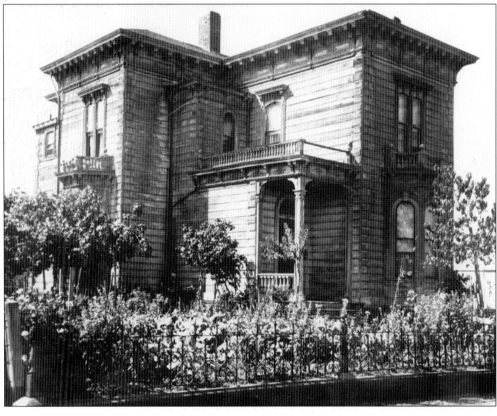

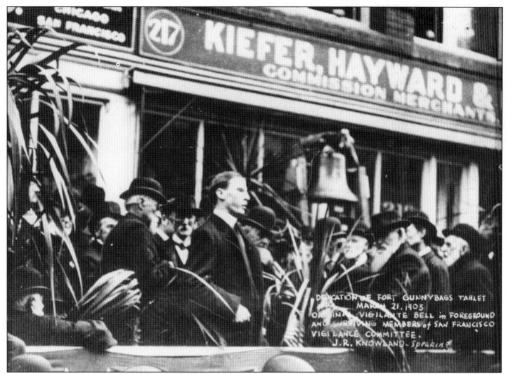

Knowland is pictured here speaking in 1903 to a group of surviving members of the infamous San Francisco Vigilance Committee. The bell is a relic from the brief but memorable era in the 1850s when the vigilance committee usurped sworn law-enforcement officers and confronted lawlessness throughout that city. J. R. was an avid student of California history and served for many years as chairman of the Historic Landmarks Committee of the Native Sons of the Golden West.

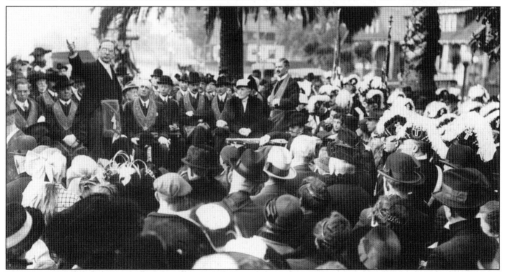

Knowland speaks at the 1917 dedication of Lincoln School in Oakland. Three years previously James D. Phelan defeated him in a close race for the U.S. Senate. With his career in elected politics at an end, J. R. turned his attention to operating the *Oakland Tribune* and, in that way, affected the future careers of other politicians for many years to come.

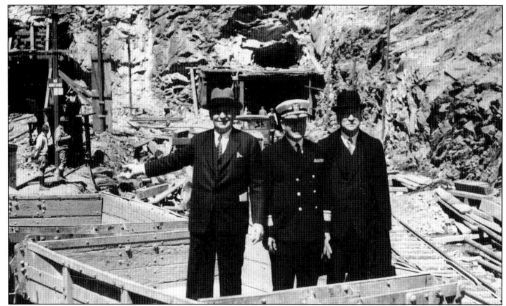

In 1934, J. R., pictured here at right, stands with Rear Adm. Thomas J. Senn and Gov. Frank Merriam on the site of the Yerba Buena Island tunnel project for the San Francisco Oakland Bay Bridge. Knowland was a staunch supporter for the bridge project, and when the $79.5 million funding for it stalled, he used his contacts in Washington, D.C., to get money allocated.

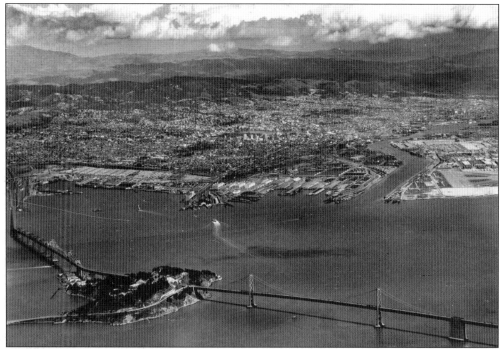

The Bay Bridge was completed in 1936, and its cantilever and suspension sections, pictured here, are anchored by Yerba Buena Island, midway between Oakland and San Francisco. The entry into the estuary of the Port of Oakland is also visible, and a Southern Pacific–owned passenger ferry can be seen making its way to the terminal, known as the Oakland Mole.

J. R. speaks to an audience of news carriers and their guests in 1943 at a wartime Christmas party held in the Oakland Municipal Auditorium.

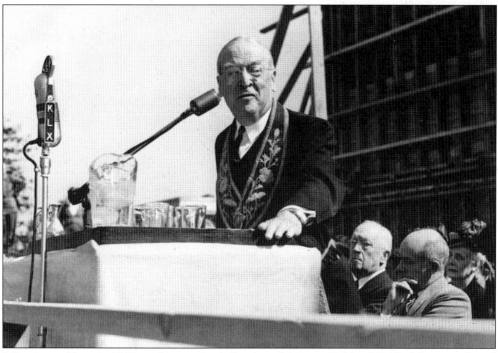

J. R., pictured here in 1949 speaking at the dedication of the new Oakland Public Library, authored *California: A Landmark History* and led the movement for restoration of the early Spanish missions. He was chairman of the state park commission from 1937 until his retirement in 1960.

William Fife Knowland, pictured here at age 5 in 1908, was only a month old when his mother died. His brother Russ was 7, and his sister Eleanor was 12. J. R.'s second wife, Emelyn, took special interest in the youngest child, who accompanied his parents to Washington while his father served in Congress. The two older children remained behind in Alameda with their grandparents. Young William was drawn to politics from an early age.

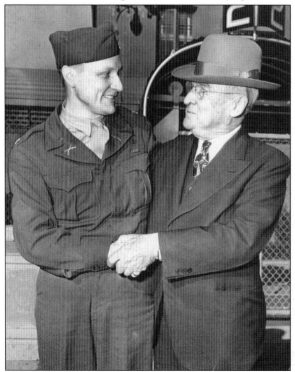

William majored in political science at the University of California at Berkeley. Like his father, he was active in the Republican party, and after graduation in 1929 and an early marriage to childhood sweetheart, Helen Herrick, William worked full time at the *Oakland Tribune* for the next few years. In the 1930s, he began his rise in California politics by becoming the state's youngest-elected assemblyman. When World War II broke out, William, at the age of 34, was inducted into the U.S. Army. He was overseas in 1945 when Republican senator Hiram Johnson of California died in office. Gov. Earl Warren, a longtime Knowland family friend and political ally, appointed William to fill the seat. He is pictured here being congratulated by his father, J. R.

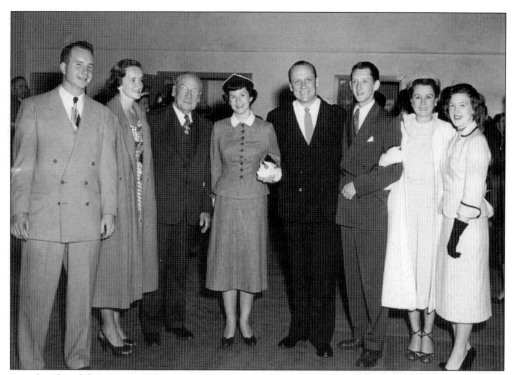

At a family celebration in 1952, some of the growing Knowland clan gathers for a portrait. Patriarch J. R. (third from left) poses with son William (fifth from left), William's wife, Helen, and their three children and their spouses.

During his years in the U.S. Senate (1945–1959), William Knowland became a close advisor to Pres. Dwight Eisenhower. This photograph was taken in 1955 as the president signed the Formosa Defense Resolution. William, second from right, was a strong proponent for supporting Taiwan and containing the communist regime in mainland China.

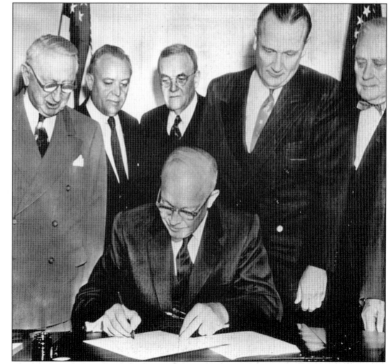

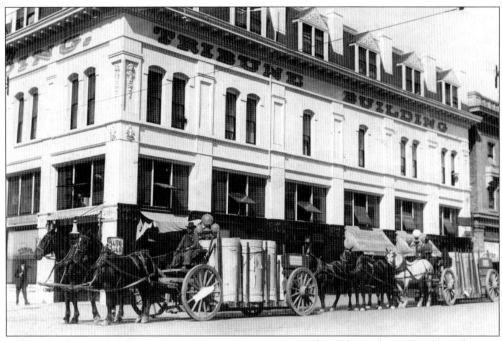

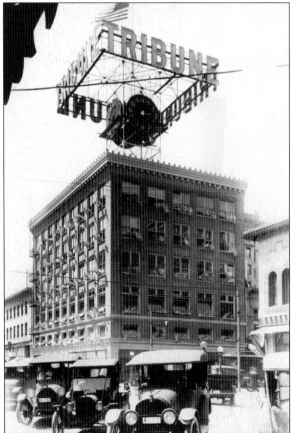

Throughout the years, the *Tribune* operated in various locations in downtown Oakland. Here is a view of the Eighth and Franklin Street headquarters, where the paper was published from 1906 until 1918. While fires raged across the bay following the 1906 earthquake, San Francisco newspapers turned to Oakland for help publishing their editions. In the immediate aftermath of the disaster, unique joint editions, put out by several papers, were the result.

Joseph R. Knowland moved the *Tribune* into this Thirteenth Street structure (formerly home to Breuner's Furniture Store) in March 1918. The 11-foot-tall Tribune letters and four-way clock faces, 15 feet in diameter, immediately began making a bold statement on the downtown skyline.

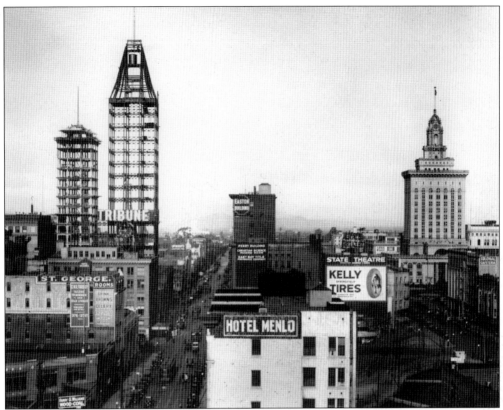

Knowland selected architect Edward T. Foulkes to design a bell tower–style addition to the existing building on Thirteenth Street, pictured here under construction in 1922. Also under construction nearby, on the northeast corner of Twelfth Street and Broadway, is the 18-story Bank of America headquarters building. News accounts at the time described the two steel frames rising above the city as a "race to the sky." At right, the already completed Oakland City Hall (actually taller, at 343 feet) can also be seen.

Born in 1874, the year the *Tribune* was first published, Edward Foulkes was raised in Oregon, graduated from Stanford University and in 1893, and also studied at Massachusetts Institute of Technology (MIT). He began his architectural career in established firms in Boston and New York City before taking the opportunity to study abroad after winning a scholarship. This view of the Tribune Tower was taken looking southeast. The city of Alameda is visible in the distance.

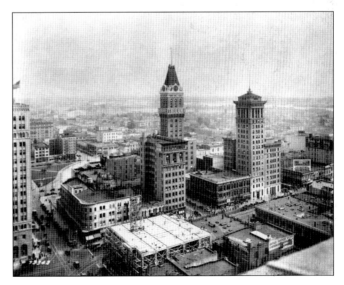

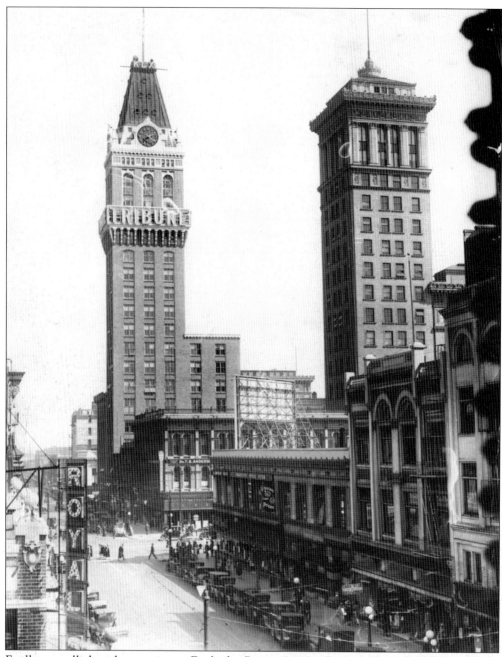

Foulkes enrolled at the prestigious Ecole des Beaux Arts in Paris and traveled extensively in Spain, England, Germany, and Italy, where he undoubtedly viewed the campanile in St. Mark's Square (thought to be the inspiration for the Tribune Tower design). Foulkes also visited India, China, and Japan while abroad. He returned to San Francisco in 1906.

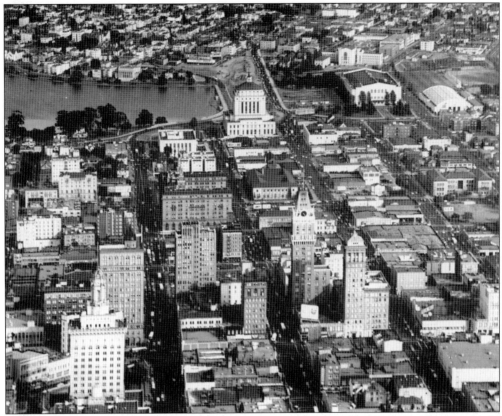

Following the devastating 1906 earthquake and fire, not only was San Francisco largely rebuilt, Oakland too (although suffering far less damage from the disaster) experienced a vigorous building boom. Trained architects, including Foulkes, found themselves in much demand during this period of rebuilding. Visible here is the tower, the Alameda County Courthouse, the Municipal Auditorium, and Lake Merritt.

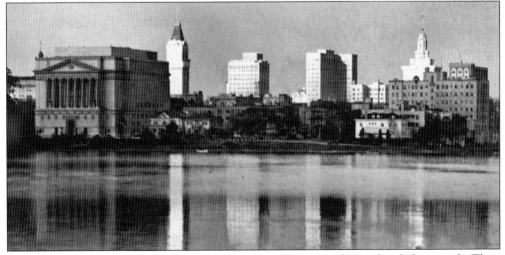

Morning sun reflects on the Tribune Tower and on city hall in this undated photograph. Their forms are reflected in Lake Merritt's calm waters.

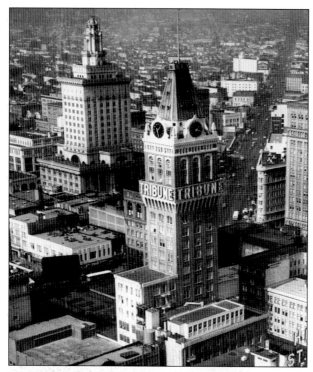

The *Tribune Yearbook* of 1924 said the tower "was meant to typify not only the home of the Tribune organization, but also the achievement of the East Bay community," standing as a "totem of the metropolitan commonwealth which has developed within the span of a human life." Both photographs are dated 1952.

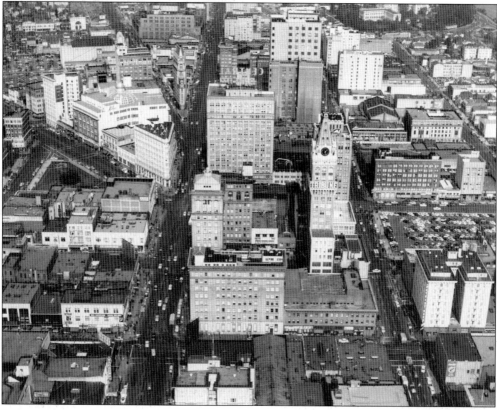

After completion, the tower could be seen from practically any vantage point downtown. In this view, Oakland's official tree, the Jack London Oak in City Hall Plaza, is in the foreground.

The first six floors of the tower were connected to the existing Tribune Building, serving as additional space for the newspaper's production. The upper stories of the tower were leased to "a select class of tenants." The 20th floor housed a radio station, KLX, which produced regular broadcasts for several years.

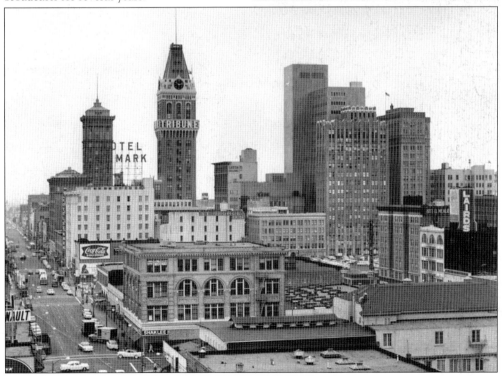

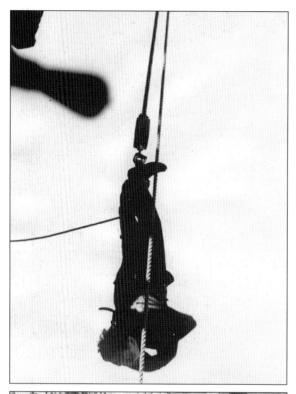

On March 27, 1923, world-renowned escape artist Harry Houdini was handcuffed, bound in a straitjacket, and suspended from the tower 112 feet above a throng of several thousand people gathered in the street below. Everyone watched as Houdini got out of his remarkable predicament as "easily as a boy takes off a sweater." Following his escape, Houdini, who was 49 at the time, gave a radio interview at the KLX radio station (located in the tower) stating his views on mysticism and life after death. He would die less than three years later from a ruptured appendix.

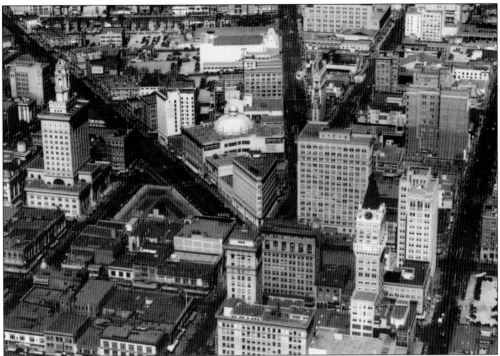

For many years, a 500,000-candlepower searchlight flashed from the peak of the tower. "The majesty and drama of the tower, with its gigantic timepiece and flashing beacon, symbolized a prestigious urban center," state the history files, "And broadcast that message throughout the Bay Area and beyond."

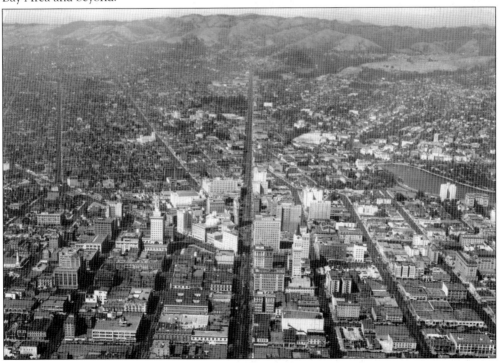

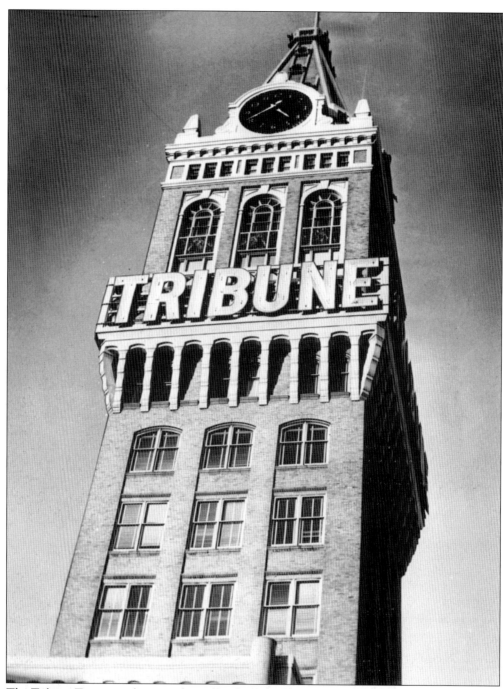

The Tribune Tower was designated an official city landmark in 1976. It is also listed as a primary reason for including the Downtown Oakland Historic District in the National Register of Historic Places.

Two

CITY BUILDERS

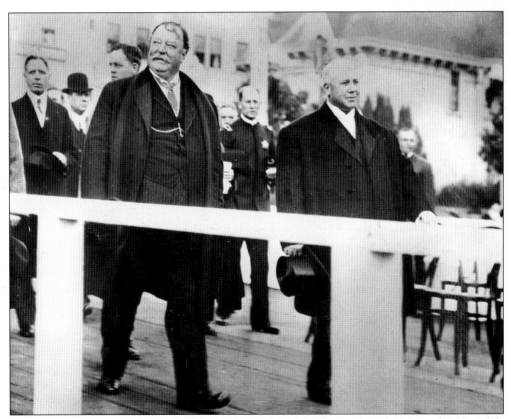

Pres. William Howard Taft, pictured here at left with Oakland mayor Frank K. Mott (1866–1958), was on hand in October 1911 to officially lay the cornerstone for a new "skyscraper" city hall to be constructed with voter-approved bond funds. The progressive-minded Mott, who had been elected in 1905, was a strong proponent of the "City Beautiful Movement," a concept adopted by many city planners nationwide during the early 20th century.

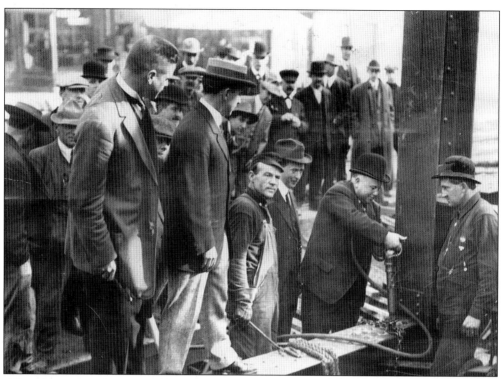

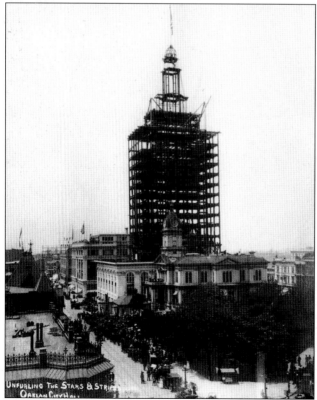

Mayor Mott drives the first rivet into the new city hall's steel frame. The structure was to be Oakland's fifth city hall (city fathers had previously met in rented rooms near the foot of Broadway and then in a wood-frame building later leveled by fire). With neighboring San Francisco's destruction fresh in voters' minds, Mott was successful in calling for a modern steel-reinforced "fireproof" structure, embellished with granite facing and terra-cotta ornament.

Construction is well underway in this image. When completed in 1914, at 343 feet, the new city hall would be the tallest building west of the Mississippi. City hall number four stands in front facing Fourteenth Street; it would soon be leveled once its stately successor opened for business.

Designed by the New York firm of Palmer and Hornbostel, who had been chosen by a blue-ribbon jury following a national competition, the innovative civic monument features a three-story podium first level, a 10-story office tower, and an ornate terra-cotta cupola. The new city hall combined ceremonial functions with daily city business. It contained hearing rooms, an elegant council chamber, a hospital ward, a fire station, and, high up beneath the cupola, sturdy jail cells for city prisoners awaiting their appointment with the judge.

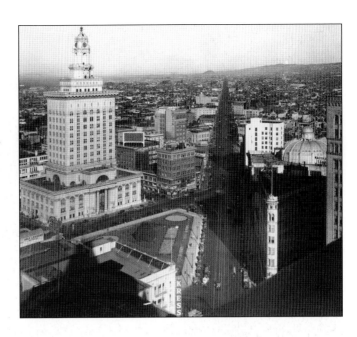

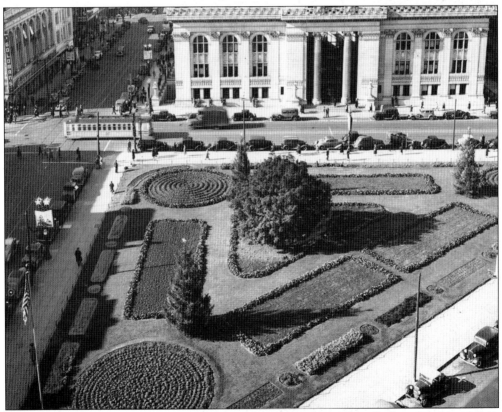

A streetcar crosses Fourteenth and Washington Streets in front of city hall in this image taken in December 1937. A close look reveals the well-manicured, triangle-shaped plaza decked out for the holidays.

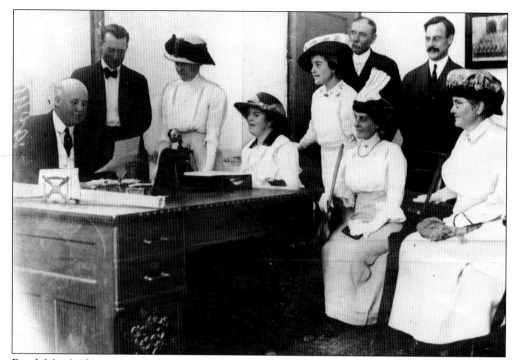

Frank Mott's 10-year term as mayor saw many progressive changes to the city. Oakland's population grew from 67,000 in 1900 to 150,000 in 1910. The explosion of growth was due in part to the influx of earthquake-disaster refugees. Mott inaugurated the city's civil-service system, reorganized the police and fire departments, built new stations, and acquired new equipment. He is pictured here meeting with a ladies delegation, perhaps discussing the newly opened public library located nearby on Fourteenth and Grove Streets that had been erected through the vigorous fund-raising efforts of the venerable Ebell Society (see chapter six).

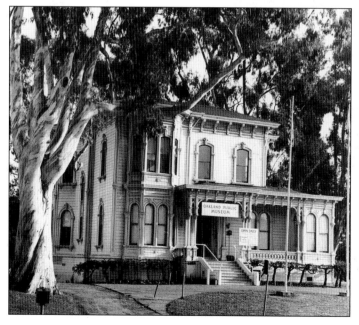

Under a newly reconstituted city charter, Mott established a park commission to oversee the acquisition of parks and playgrounds. A lovely Italianate-style mansion, built in 1876, that overlooks Lake Merritt and was previously home to a series of prominent Oakland families was acquired as the city's first public museum. Improvements were also made to the grounds surrounding the lake, which was dredged to a greater depth to allow for boating and other water pursuits.

During Mott's tenure, two historic properties were acquired for public use. Pictured here is the entrance to Mosswood Park, with Mayor Mott at the gate. The estate, with lawns, exotic plants, and mature trees, had once belonged to early pioneer Mora Moss and his wife, Julia.

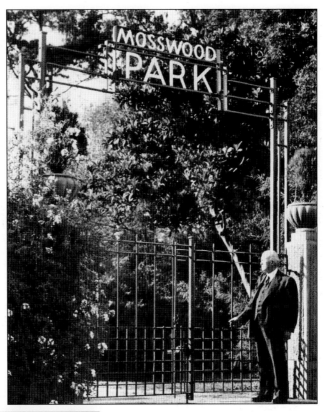

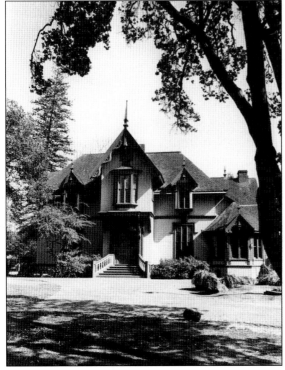

Mosswood Cottage, located on the park's grounds and notable for its distinctive Carpenter Gothic-style detail, has been used for various community activities over the years, including a preschool and an art studio.

29

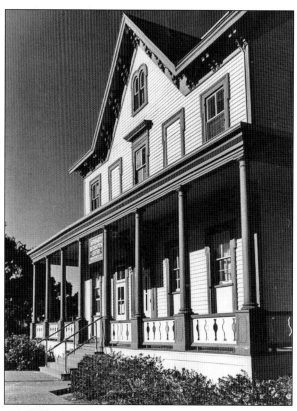

Early settler James deFremery built this pitched-roof, batten board house with a wraparound verandah in the 1860s. The home, surrounded by spacious grounds, was on Adeline and Sixteenth Streets in a residential district west of downtown. Mr. deFremery commuted by ferry to San Francisco, where he had a thriving import and banking business. Like many San Francisco executives of that era, he preferred the balmy climate and flatter terrain of the East Bay to his family's residence. In 1907, Mott's administration purchased the estate for $135,000 from deFremery's descendants in order to create a park and playground for public use.

A public swimming pool for Oaklanders was later built on the deFremery property, where lessons and aquatic activities continue to be popular to this day.

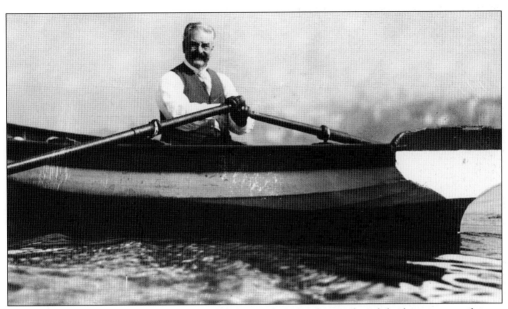

Mayor Mott's successor, John L. Davie (1850–1934), was a larger-than-life character—a former mule skinner, cattle driver, butcher, opera singer, bookseller, and ferryboat operator. Davie served four successive terms as mayor, finally retiring in 1931 at age 81. During the Davie era, Oakland greatly expanded in size, annexing an additional 44 square miles by absorbing nearby townships east of Lake Merritt. Mayor Davie is pictured here rowing on Lake Merritt, a frequent and favorite pastime.

Mayor Davie, pictured at left in 1929 on horseback with fellow politician James Rolph, was a tremendous booster for Oakland, overseeing the establishment of the maritime port and airport facility (Oakland's commercial airport was one of the first in the country), as well as the creation of a publicly controlled water district and the opening of a regional park system. Oakland became known as the "Detroit of the West" when Chevrolet and General Motors opened assembly plants, as they were attracted to a city where "rail, road, and water meet." Food processors, canneries, cotton mills, and machinists also developed business sites in Oakland's flatland districts in proximity to the rail and shipping lines.

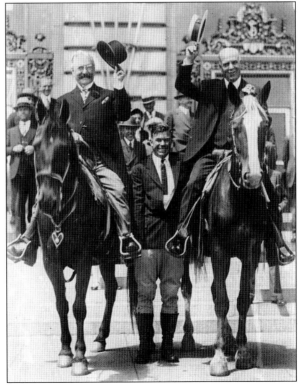

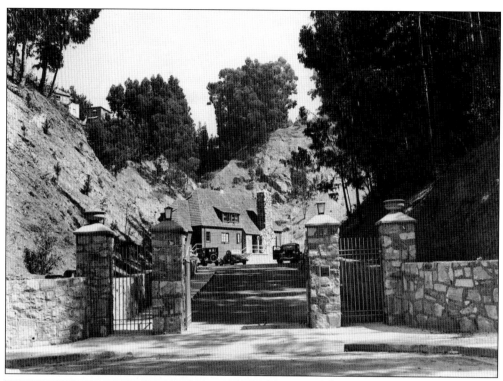

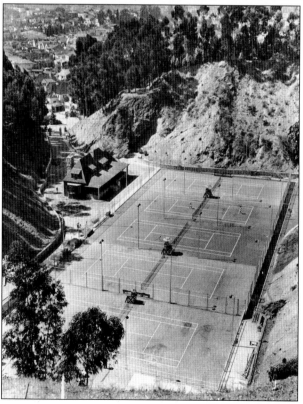

After stepping down as mayor, Davie made a gift to the city of a clubhouse and tennis stadium intended for the public's use. It was located in what had once been a rock quarry near the boundary with the city of Piedmont. The scene of many tennis tournaments over the years, several of the state's best-known competitors have come here to play.

George C. Pardee (1857–1941), pictured here receiving congratulations following his election in 1903 as governor of California, was born in San Francisco and raised in Oakland, making him the first native-born Californian to serve in that office. His father, Enoch, a gold-rush forty-niner and a physician by profession, was active in state and local politics in the 1870s and 1880s. George, an only child, followed in his father's footsteps by studying to become a doctor and like his father, serving as mayor of Oakland from 1893 to 1895. During his four years in Sacramento, Pardee, a progressive Republican, maintained close ties with Pres. Theodore Roosevelt and promoted conservationist causes, such as preserving Yosemite Valley as a national park.

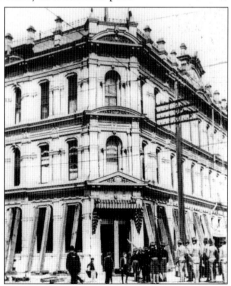

Pardee is remembered as the "earthquake governor" because he oversaw the response and later recovery after the 1906 earthquake, the worst urban catastrophe in U.S. history. The damaged structure in this photograph is the Oakland Bank of Savings at Broadway and Twelfth Street. Wood braces keep the building from collapsing. Once Pardee got word of the temblor, he rushed back from Sacramento and set up a response headquarters in his former city-hall offices. Within hours, the first of what would grow to many thousands of people fleeing the flames in San Francisco arrived seeking shelter and relief. Oakland's emergency response lasted for months.

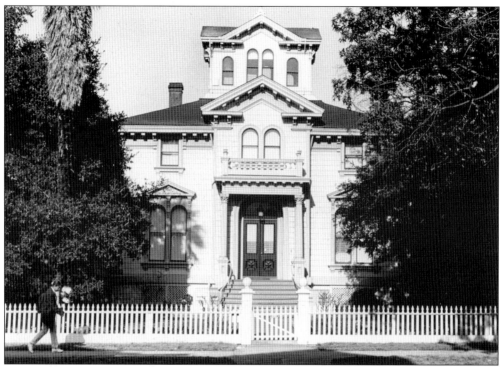

Three blocks west of city hall and built in 1868 by Governor Pardee's parents, Enoch and Mary, the Pardee home on Eleventh Street continued to be occupied by family members until granddaughter Helen died in 1981 at the age of 86. Helen's will established a trust to maintain her family's longtime home and make it available for public tours.

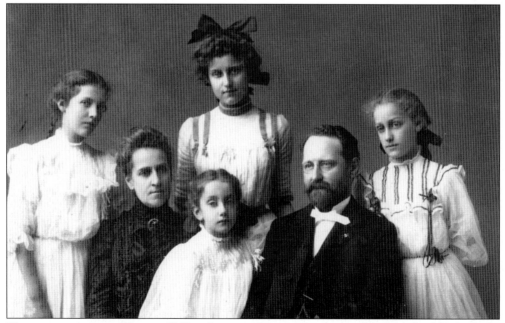

The governor is pictured here in 1903 at the time of his inauguration with his wife (and former high-school sweetheart), Helen, and their four daughters, Madeline, Helen, Florence, and Caroline.

Returning to Oakland in 1907 after serving a single four-year term in Sacramento, Pardee devoted the remaining years of his life to improving his hometown. In 1927, he was named to the Port of Oakland Board to oversee the modernization of that facility. He also served as president of EBMUD, the region's publicly owned water company, until his death in 1941.

From the time Oakland was designated the western terminus of the transcontinental railroad line in 1869, its importance as a transit hub continued to grow. This photograph dates from 1909 and shows cargo being transferred from Southern Pacific train cars to vessels docked on the Oakland Long Wharf, which extended two miles out in the bay. Southern Pacific's longtime, exclusive control of the harbor was about to come to an end due to court rulings during Mayor Mott's administration. The Port of Oakland Board, with former governor Pardee at the helm, would help guide the port into the modern era.

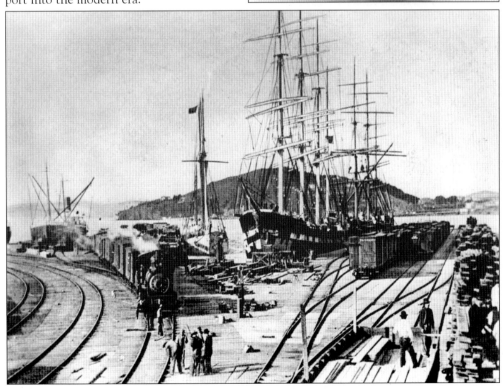

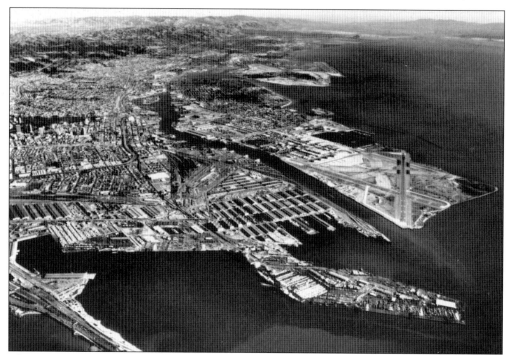

The Port of Oakland's estuary channel can clearly be seen in this undated photograph. The island city of Alameda is at right, and Oakland's port facilities are at left. Alameda became an island in 1901, after the Army Corp of Engineers dredged a channel, cutting the narrow peninsula connecting the two communities, through to San Leandro Bay to the south, thus deepening the harbor to accommodate larger ships.

The completion of the Panama Canal in 1914 (supported by Joseph R. Knowland when he was in Congress) resulted in a rise in Pacific Rim trade and shipping, thereby further enhancing Oakland's position as a key West Coast port. The local shipbuilding industry also became increasingly important as World War I got underway. In 1928, the Port of Oakland was declared an official port of call to the United States. With this designation, ships under foreign registry no longer had to clear customs first at the Port of San Francisco before off-loading in the East Bay. By the mid-1930s, Oakland was a port of call for 40 world-shipping lines, and cargo tonnage had more than doubled.

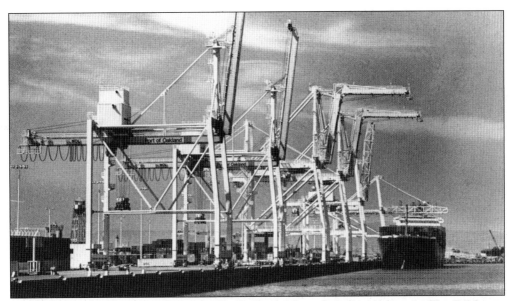

In the 1960s, the Port of Oakland, under the leadership of executive director Ben E. Nutter, made the technological advance from traditional break bulk-cargo off-loading methods, to containerization, using 10-story cranes with a single operator at the controls. The newly installed dockside cranes had lifting capacity of up to 50 tons and could handle the standardized steel containers arriving by truck or rail in a fraction of the time it used to take using the old methods. The new technology signified a far-reaching change in cargo handling, and Oakland's port was one of the first in the world to embrace it.

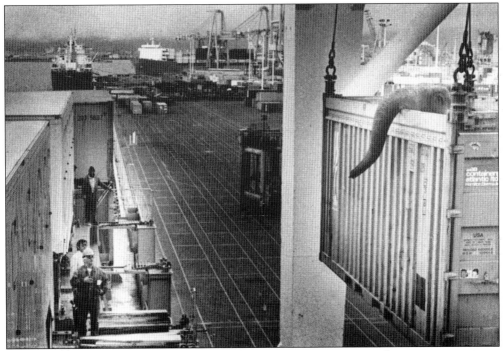

A curious Ringling Brothers circus elephant tries to explore its surrounding as its container is about to be hoisted aboard a waiting ship by one of the port's cranes in this 1988 photograph.

Francis Marion Smith (1846–1931) was a Wisconsin-born prospector who in 1872 struck "pay dirt" upon discovering a lode of the valuable mineral borax in the desert near Death Valley. Smith and his brother transported the unrefined crystalline substance out of the desert in wagonloads pulled by mule teams. Smith chose the East Bay to establish the plant facility that would refine and package the mineral for use in American kitchens (as a cleanser and water softener). In five years, production of borax tripled to 11 million pounds, and Smith's fortune would eventually grow to $20 million.

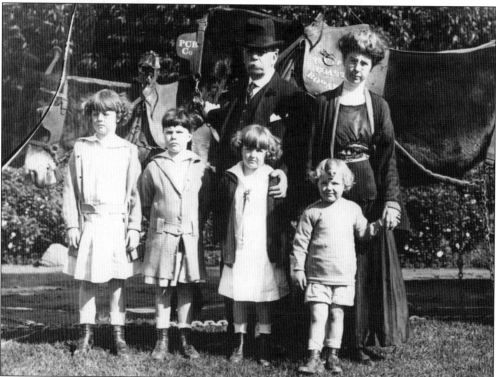

In 1881, Smith, pictured here with his family, moved to Oakland to be near his Alameda refinery. He began investing his millions in real estate, forming the Realty Syndicate in 1895 with partner Frank Havens and buying land in outlying areas beyond Berkeley, Piedmont, and Oakland. The partners also acquired and consolidated a number of small, independent transit companies so they could create an integrated system of streetcar lines throughout Alameda County. Rail extensions were built out to the Realty Syndicate's property holdings, where new subdivisions were being created. Smith and Havens correctly foresaw the coming demand for new homes, as the county's population soared after 1906.

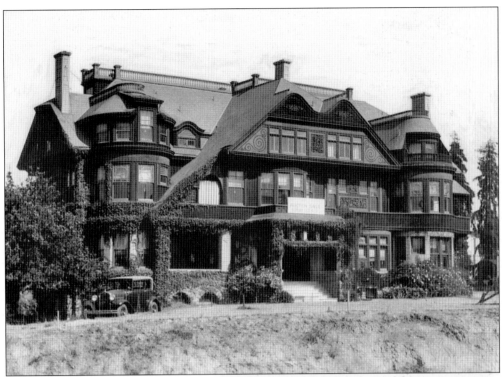

"Borax" Smith, as he came to be known, built his own grand estate called Arbor Villa on a hilltop east of Lake Merritt off of Park Boulevard. His rambling mansion pictured here and designed by prominent local architect Walter Mathews, contained 42 rooms, including a ballroom and an indoor bowling alley. Tame deer and peacocks roamed the elaborately landscaped grounds and Mr. and Mrs. Smith entertained often and lavishly.

The Smith home was "filled with art treasures, murals, rare fine woods, a pipe organ and luxurious furnishings." Nearby were a number of cottage residences staffed with housemothers who looked after and instructed orphaned girls, supported with private trust funds established by the Smiths. Although the mansion was demolished in the 1930s after Smith's death, several of the cottages still remain standing.

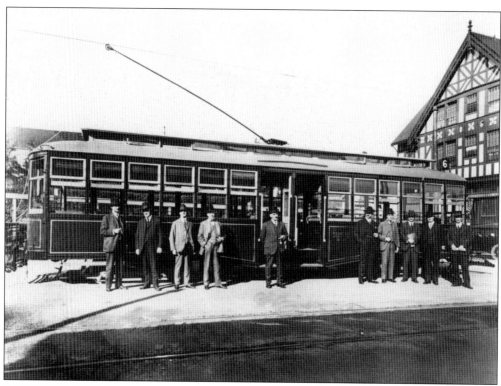

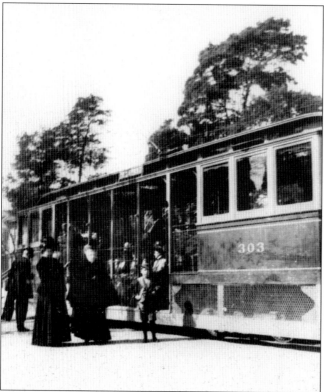

A deluxe new streetcar awaits passengers in this 1915 image, with the grand Key Route Inn partially visible on the right. Pres. William Howard Taft stayed at this hotel when he came out to Oakland to lay the cornerstone of city hall. Borax Smith had the hotel built in Tudor Revival style, with half-timbered detailing and a streetcar station located right in the building. The hotel's architect was Edward T. Foulkes (Tribune Tower). Could the architect's inspiration have come from his travels abroad? No one can state for certain.

Smith's transit company was officially called the San Francisco, Oakland & San Jose Railway, but everyone was soon calling it the Key System (see page 44).

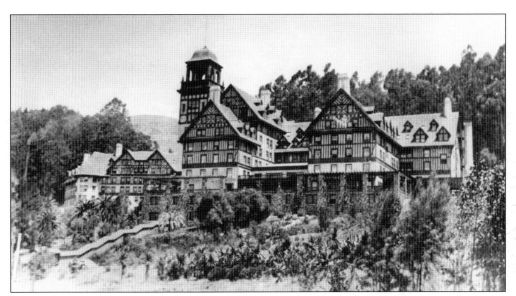

Also half-timbered and a prominent end-of-the line destination on the Key Route Line was another of Smith's developments, the picturesque Claremont Hotel, pictured here around 1915. Developers were erecting hotels at this juncture for tourists flocking to California to attend the Panama Pacific International Exposition across the bay in San Francisco. Barely a decade after the 1906 disaster, San Franciscans were eager to show the world their city was rebuilt and functioning again. Set amidst lavish grounds and graced with sunny weather and breathtaking bay views, the Claremont Hotel was less than an hour away by streetcar and ferry to the grand expo.

For generations of Bay Area residents throughout the years, the Claremont Hotel has been the site for banquets, weddings, and special occasions. The main banquet room, with its finely stenciled ceiling, is pictured here in 1937. Alterations have occurred over time, and the hotel exterior is now painted a creamy white, but its historic landmark status remains intact. Located on the Oakland/Berkeley border, the Claremont is listed on the National Register of Historic Places.

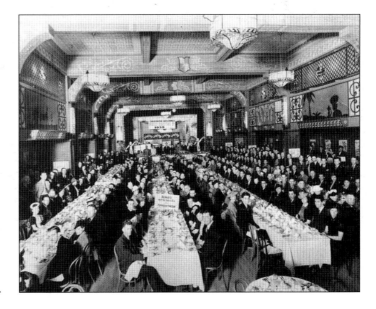

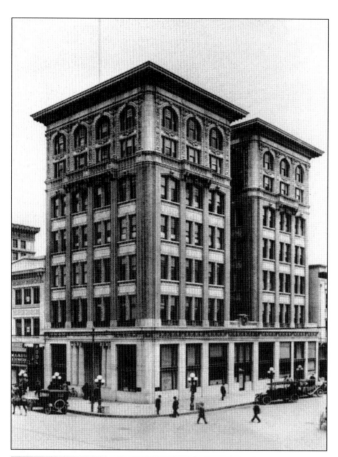

The Key System's headquarters, pictured here in this *c.* 1910 photograph, was located downtown at Eleventh Street and Broadway. The structure was erected in 1911 during the post-1906 downtown Oakland building boom.

At the height of its popularity during the 1940s, the Key System trains operated in Oakland, Berkeley, Emeryville, Piedmont, San Leandro, Richmond, Albany, and El Cerrito on 66 miles of rail line. Also carrying riders during this time were the competing Southern Pacific-owned "red cars" that transported passengers out Seventh Street to the Oakland Mole for the 28-minute ferry ride into "the city."

As early as 1916, when this photograph was taken, the automobile was beginning to make its presence felt, ultimately dooming streetcar networks. This is Twelfth Street, just east of the lake. The mansion at right was the home of Erminia Peralta Dargie, widow of one-time *Tribune* publisher William Dargie.

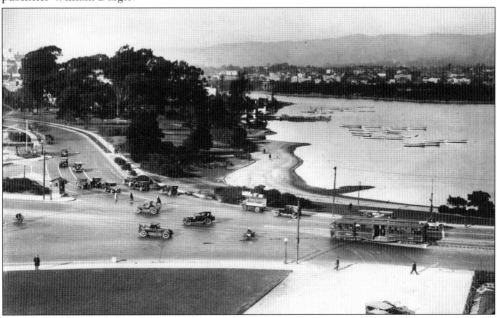

This is another lakeside view, undated, from Twelfth Street. More and more private automobiles were competing for space on city streets. The streetcar lines will one day be removed to make way for buses (see page 46).

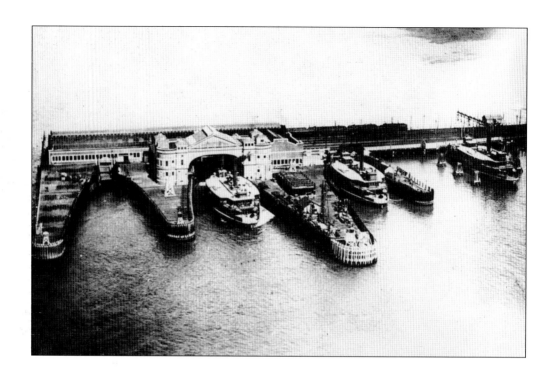

The Key System Ferry pier and terminal, built in 1903, was located three miles out from the East Bay Shore, almost to Yerba Buena Island. During the system's heyday in the mid-1930s, prior to the completion of the bay bridge, there were 43 ferries operating daily, with eight million riders crossing annually. The system's nickname stemmed from the way the long pier resembled the shaft of an old-fashioned house key. Note how the ferry slips looked like the key's "teeth" (above).

After the bay bridge opened in 1936 and automobile ridership started to climb, fewer and fewer commuter passengers elected to take the ferry over to San Francisco. Eventually determined to be too unprofitable to keep running, ferry service was terminated in the late 1950s. Ironically the ferries would be brought back into operation in 1989 when the bay bridge was temporarily shut down due to damage caused by the Loma Prieta earthquake.

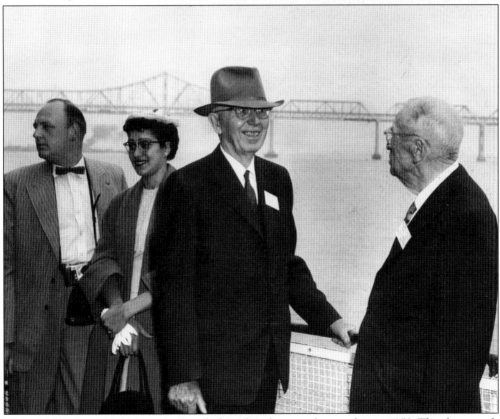

The transbay ferries' days were numbered when this photograph was taken in 1958. The photograph caption states Joseph R. Knowland, pictured at far right, and fellow passenger Otto Fisher are reminiscing about taking ferry rides dating back to when they were boys in the 1870s.

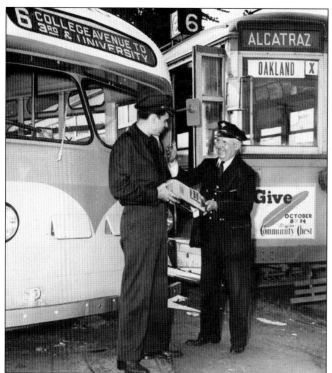

A streetcar on the College and Alcatraz Avenues No. 6 Line makes its final run on September 29, 1946. Motorized buses take over from this point on, signifying the end of an era.

The Alameda–Contra Costa Transit District, which is managed by publicly elected directors, was voted into existence in 1953. The directors used $1.6 million in bonds to purchase the assets of the streetcar company. Many of the bus routes today follow closely the routes used at the turn of the 20th century by the old Key System trains. In six of the past nine years, AC Transit has been named the nation's most outstanding public bus agency.

Borax Smith's once grand Key Route Inn was damaged in a fire and was demolished in 1932.

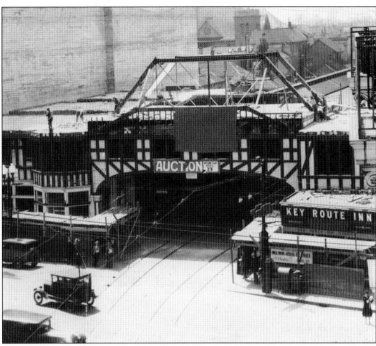

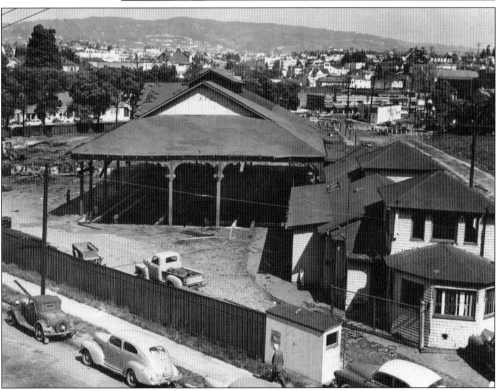

Key System carbarns, on Second Avenue east of Lake Merritt, are taken down in 1950 to make way for a new shopping center designed with plenty of off-street parking for cars. In the distance, the landmark Parkway Theater sign is visible to the right.

Officials hold a mock funeral in January 1939 for the ferryboat *Piedmont*, ending its daily run from Alameda to San Francisco.

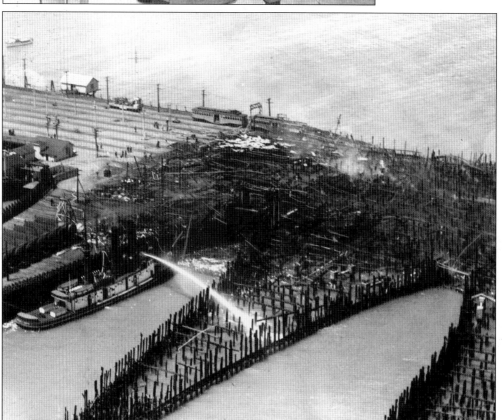

A fast-moving fire has destroyed the Key Route terminal in this 1933 image.

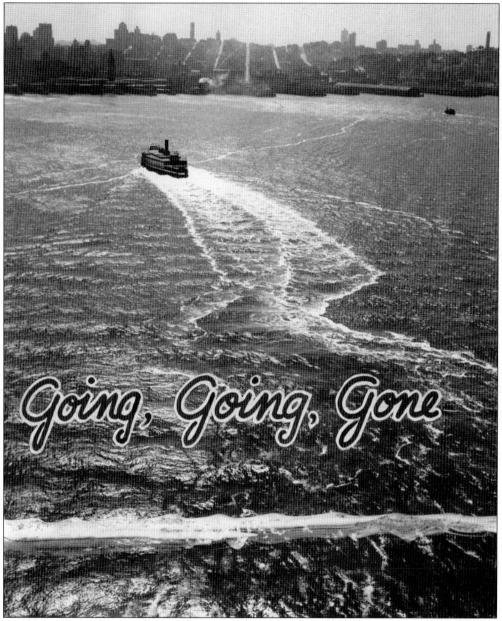

The caption for this photograph that ran in the November 3, 1957, *Tribune* reads, "Goodbye, old floating dodos, they say you're obsolete! So long, you hardy remnants of the once proud Ferry Fleet! It's Destination Sunset and farewell to golden dawn—You're on your way to limbo, you are Going, Going, Gone."

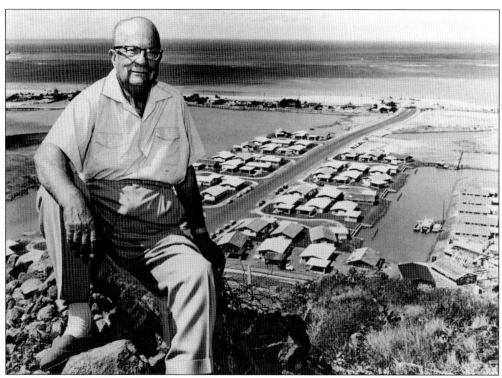

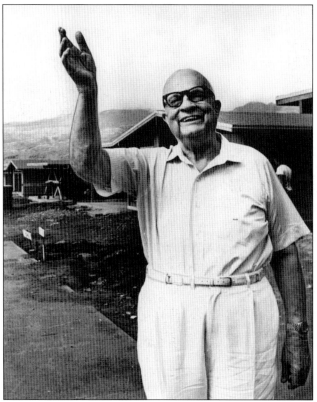

A man of modest origins and limited formal education, industrialist Henry J. Kaiser (1882–1967) has been ranked the 11th most influential businessman of all time by *Forbes* magazine. A builder of roads, dams, ships, automobiles, and housing, he established over 100 companies and for more than 40 years oversaw his far-flung interests from his home-base corporate headquarters in Oakland. A "can-do" capitalist, he was still fair and equitable with his employees, worked cooperatively with their unions, and established a health-care benefit program that was the prototype for today's HMOs.

Born in upstate New York, Kaiser quit before finishing high school, came west at age 23, and started a road-paving business in Vancouver, British Columbia. For several years he traveled throughout the western region wherever there were paving contracts to bid on. In 1921, married with two sons, Kaiser decided that Oakland would be his home base. A modest office, desk, and chair used from early in his career are pictured here.

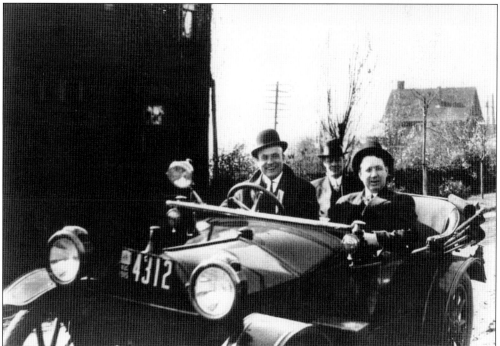

Kaiser, the young entrepreneur at the wheel in this 1915 photograph, took up road building when the growing popularity of automobiles dictated that freeway networks be constructed quickly and efficiently. Kaiser consistently completed his contracts under budget and earlier than the deadline.

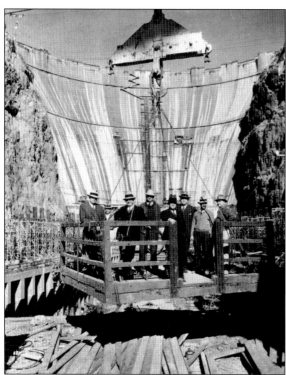

Government infrastructure contracts, such as dam building, came next. His company, along with six others, worked together on the Hoover, Grand Coulee, and Shasta Dams during the 1930s. Kaiser also worked on Mississippi River levees and the underwater foundations for the San Francisco–Oakland Bay Bridge. In this photograph, Kaiser is second from left.

Kaiser is pictured here with bandleader Guy Lombardo at Lake Tahoe in 1949. "I always have to dream up there against the stars," Kaiser was quoted as saying, "if I don't dream I will make it, I won't even get close." He also said, "I make progress by having people around me who are smarter than I am and listening to them. And I assume that everyone is smarter about something than I am."

As part of his business strategy, Kaiser formed subsidiary companies in order to create sand and gravel processing plants and steel mills, thereby supplying his own materials for job sites. This photograph of Kaiser, with one of his blast furnaces in the background, was taken in 1942.

Kaiser's Richmond shipbuilding facilities produced Victory Ships for the war effort in the 1940s at an unbelievable pace of one vessel every five days. By war's end, 1,490 ships had been fabricated for maritime use.

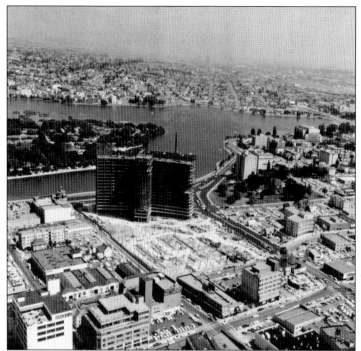

In 1954, Henry Kaiser's agents paid over $2.5 million for the lakefront Holy Names College campus site (see page 57). Los Angeles–based Welton Beckett and Associates was called upon to design a new headquarters complex for Kaiser's multinational corporation. Completed in 1960, it was reportedly the largest office building west of the Rockies. At 28 stories and 390 feet in height, the Kaiser Center is a dramatic example of the International style.

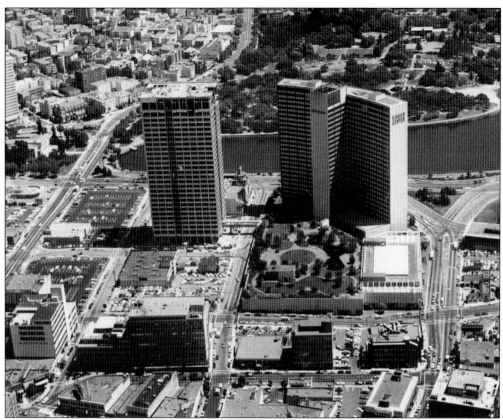

The complex at Twentieth and Harrison Streets was soon joined by the adjacent Ordway Building (Skidmore Owings Merrill, 1970), which is 404 feet tall and has stunning views of the lake and Oakland hills. Mr. Ordway was an early key associate of Kaiser's. Also visible in this aerial photograph is the innovative two-acre rooftop garden (located atop the complex parking garage). The design for the garden is attributed to landscape architect Theodore Osmundson. One of the first such "roof" gardens, it would be emulated elsewhere in commercial building complexes around the country.

This nighttime illuminated view highlights the structure's glass-curtain wall façade, composed of gold-aluminum alloy panels (a Kaiser Company product) set in natural finish aluminum mullions. The 5,000 windows are tinted gray and glare resistant. Office workers enjoyed breathtaking views.

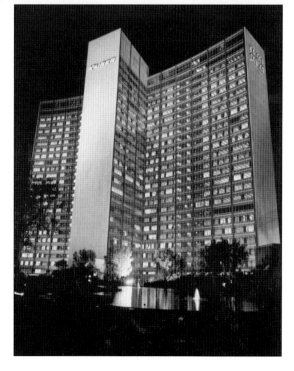

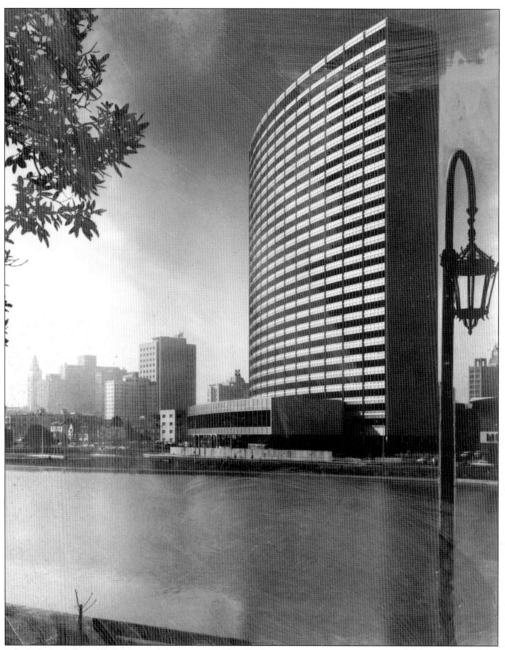

The Kaiser Center's distinctively curved lakeside frontage seems to, as one art critic phrased it, "cordially turn toward you" at every vantage. Kaiser had only a short time to enjoy his crowning achievement. He died in 1967 at the age of 85. In this portrait of the Kaiser Center, the Tribune Tower is visible at far left.

Three

OAKLAND
ATHENS OF THE WEST

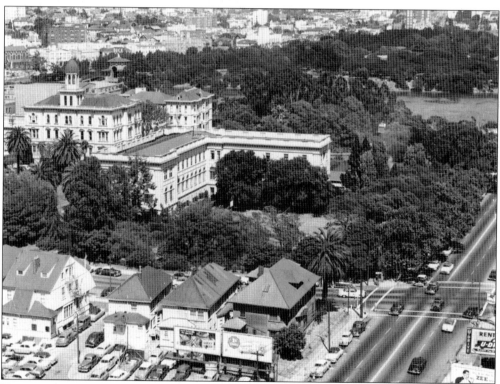

Historic Holy Names College was ensconced for 80 years on the lakefront acreage that would one day become the site of the Kaiser Center complex. Founded in 1868 as a convent by six Catholic nuns from the Sisters of the Holy Names of Jesus and Mary of Canada, the school began granting liberal arts degrees to secular students in 1917.

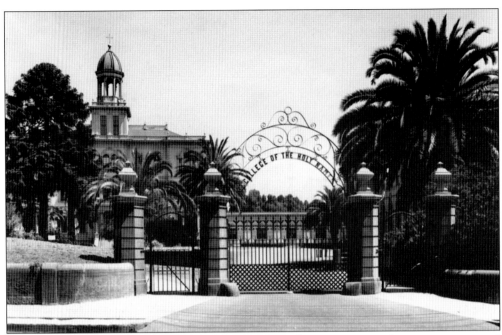

The convent school took advantage of its shorefront location once a dam was constructed across Twelfth Street, creating a lake out of what had formerly been a marshy tidal slough. The lake was subsequently named for early mayor Samuel Merritt, the man who came up with the funds to build the dam back in 1869. Soon the campus would include an orchard, a rockery and aquarium, an aviary, a summerhouse, and a lakefront park with curving pathways. Holy Names coeds in rowboats would frequently be seen out on the water with their Sister chaperones, clad in black, in attendance.

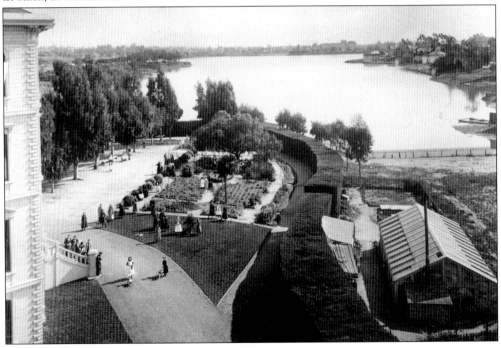

Holy Names College seniors, the class of 1956, gaze out from their chapel's cupola as the final group to graduate from the old campus.

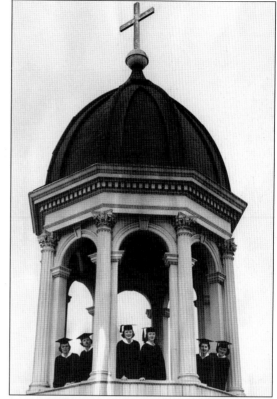

The college made the move to its hillside location in 1957. Proceeds from the sale of the Lake Merritt property made it possible to build a brand-new campus overlooking Redwood Road and the Warren Freeway (Highway 13). Holy Names became coeducational in 1971 and was officially renamed Holy Names University in 2004.

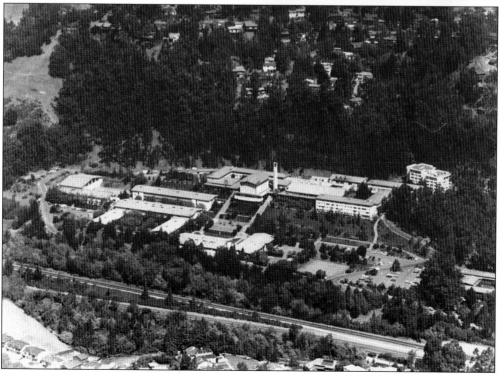

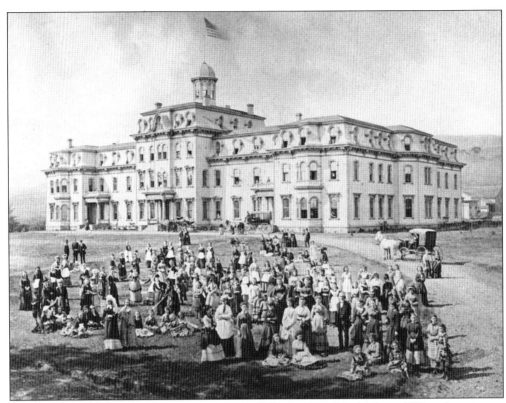

Mills Hall, of Oakland's Mills College, pictured above when first built in 1871 and in a more contemporary state below, initially served all of the institution's needs with classrooms, dormitories, faculty housing, and offices. The most striking contrast between the two views, besides the cars, is the abundance of towering trees in the later view. Cyrus Mills was said to be a great lover of trees and plants, stemming from his days as a missionary in the Far East. Thus during his tenure as head of the college, he planted many diverse and hardy specimens throughout the 135-acre campus.

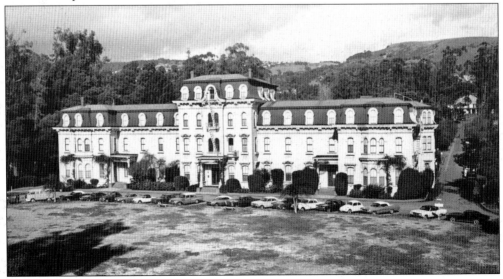

Founded in 1852 as the Young Ladies Seminary and located at the then-state capital of Benicia, the school was acquired by Cyrus and Susan Mills in 1865. The couple decided to move the seminary to a rural site east of Oakland in 1871, where daughters of West Coast families desiring an "east coast education" closer to home soon flocked to enroll. By 1885, the lower grades had been discontinued and Mills was chartered as a four-year liberal arts college. Cheerful coeds of the class of 1908 are pictured here.

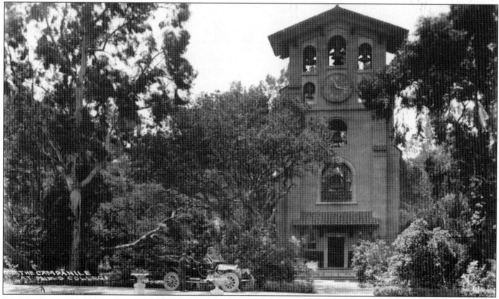

The unique campus campanile bell tower in this photograph was erected in 1904 and designed by California's first female licensed architect, Julia Morgan. The bronze bells were a gift from Mr. and Mrs. Smith (of Borax fame, see chapter two) and came from the 1903 Columbian International Exposition in Chicago. The structure Morgan designed is a very early example of reinforced concrete, and it withstood the 1906 earthquake with little or no damage. This fact did not go unnoticed, and her architectural services were soon in great demand in the post-earthquake rebuilding period (see chapter five).

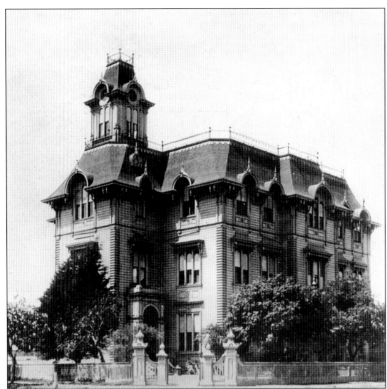

Oakland's first high school stood on the northwest corner of Twelfth and Market Streets from 1871 until 1879. It was the second high school in the state. By the next decade, in addition to the public high school, there were nine elementary schools and a number of well-regarded private schools located in Oakland, earning the city the nickname "Athens of the West."

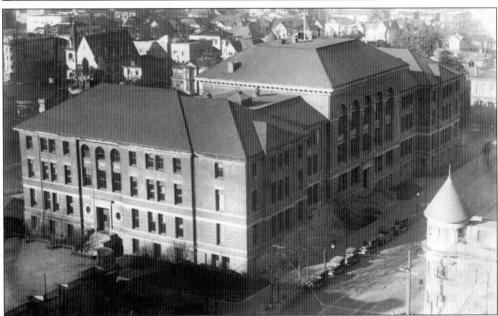

Following a fire that heavily damaged the old Market Street campus, Oakland High students began attending classes in a newly constructed school building on the block of Twelfth Street, between Jefferson and Grove, pictured here. In the 1920s, this school too would become outdated (see next page). Over the years, notable graduates of Oakland High would include George Pardee and his wife, Helen, as well as Julia Morgan and Jack London.

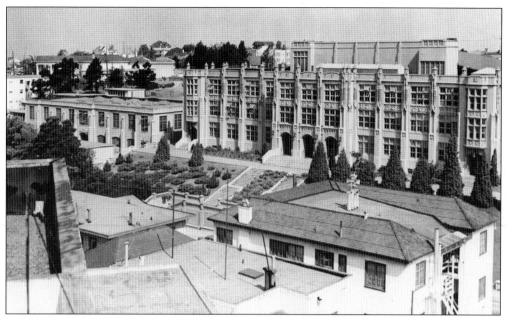

Oakland High moved yet again to a hilltop off of Park Boulevard in 1928, reflecting the growth of East Oakland neighborhoods following the end of the World War I.

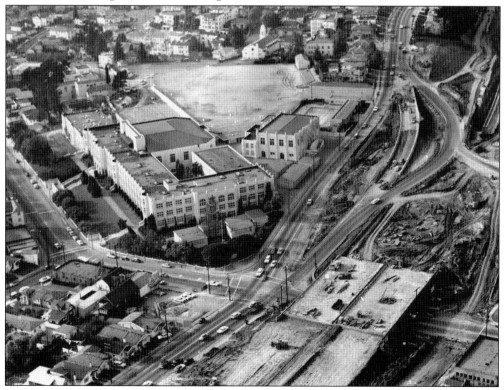

In this 1961 image, the MacArthur Freeway (Highway 580) is under construction just north of the high school campus. New state earthquake standards for schools would soon doom Oakland High's stately Tudor Revival–style main building (see chapter six).

Pictured here is the elite University High School located on Grove Street near the boundary with neighboring Berkeley. Designed by prominent local architect Charles W. Dickey in 1922, the institution was intended as a "feeder school" for students planning to enroll at the Universtiy of California, Berkeley. Later the school became a junior college for returning World War II veterans. Huey Newton and other early members of the Black Panthers attended there in the 1960s. In the 1980s, the former high school stood sadly vacant. After years of neglect, the building was fully renovated. Now a city landmark, it houses a senior center and a medical research facility.

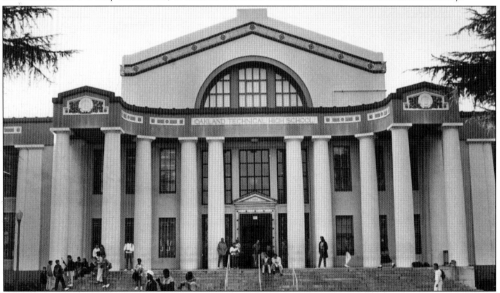

Oakland Technical High School, located on Broadway, opened in 1914. The architect was John J. Donovan, Oakland's city architect at that time. Later in his career, Donovan became well known for designing schools throughout California; his textbook on the subject greatly influenced other school architects. In the 1970s, Oakland's school board voted to commit funds to renovate "Tech High," and so it too was spared the wrecking ball (see chapter six).

East Oakland High School, later called Castlemont, located on MacArthur Boulevard, opened in 1928. The structure won a design award from the building industry when it first opened, but unfortunately it did not survive. In 1960, it was found to not meet earthquake standards and was replaced.

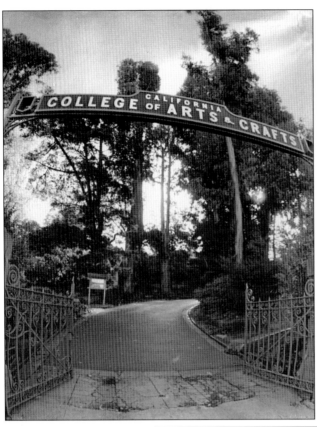

California College of Arts and Crafts was founded by German cabinet artisan Frederick Meyer in 1907. The school's first home was in Berkeley. Meyer had been forced to leave San Francisco, where he had been teaching at the Mark Hopkins Institute of Art, because of the 1906 earthquake and fire. Meyer moved his art school to a four-acre estate on Broadway at College Avenue in Oakland in 1922.

This c. 1880s Victorian house, formerly the home of a James Treadwell who had once operated a successful Alaskan gold mine before moving to Oakland, was converted into classrooms, administration offices, and on the top floor, living quarters for Meyer and his family. Other campus buildings would be added over the years, but the bucolic feel of a secluded 19th-century estate would remain, thanks in part to Professor Meyer's horticultural interests. In 2003, the institution's name was changed to California College of the Arts.

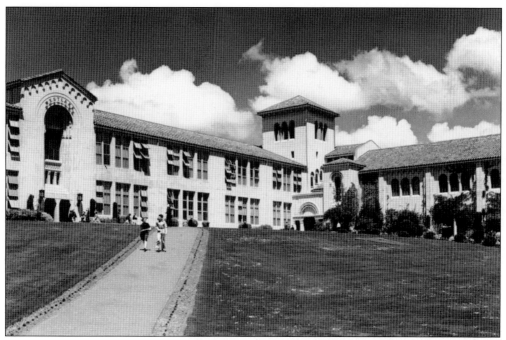

Westlake Junior High School on Harrison Street, built in the 1920s, following architect Donovan's principles of light-filled classrooms, also featured a Mediterranean-style tiled roof and monastery-like square tower. It too met the wrecking ball in the 1970s (see chapter six).

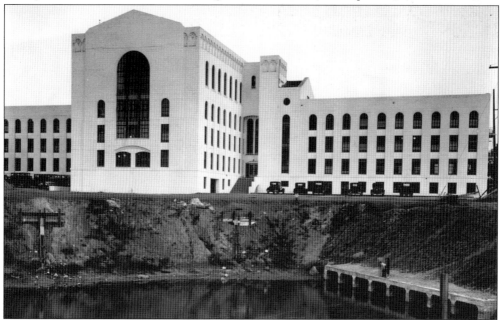

In this image, the newly completed and imposing Oakland School District Administration Building stands across Lake Merritt channel from the landmark Municipal Auditorium (see chapter six). The placement of this facility was in keeping with a planned civic-center district destined for the Twelfth Street end of the lake. The county courthouse, the museum, and the main public library building were also located nearby.

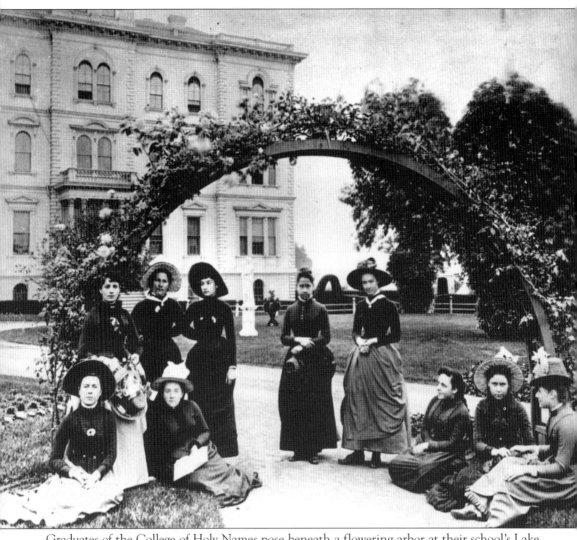

Graduates of the College of Holy Names pose beneath a flowering arbor at their school's Lake Merritt campus in this charming 1890 photograph.

Four

PARKS AND GARDENS

Starting in the 1890s, Borax Smith's Realty Syndicate began operating Idora Park, an amusement park in north Oakland that was easily visited via the Telegraph Avenue streetcar line. The 17-acre park soon became a popular destination with a "scenic railway" (an early version of the roller coaster), a dance hall, zoo, picnic grounds, children's playground, vaudeville hall, and swimming pool or "plunge," as it was then called.

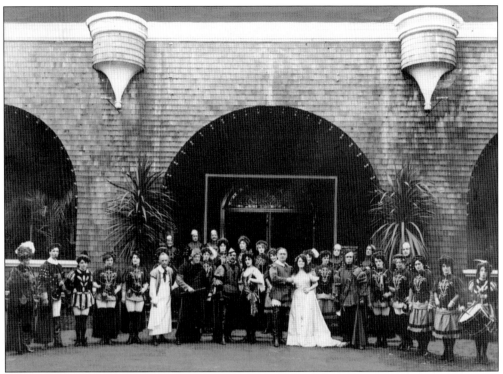

Opera Companies, such as the one pictured here, would give regular performances at Idora Park. Nighttime crowds were attracted to the pavilion buildings, illuminated with strings of electric lights, visible in this 1906 photograph, courtesy of the newly formed Pacific Gas and Electric Company. During the early years of the 20th century, electric lights were still very much a novelty.

Bathing beauties parade along the edge of the Idora Park's outdoor swimming pool in this *c.* 1920 photograph.

After the 1906 earthquake, Idora Park became a temporary refuge for several hundred people fleeing the fires across the bay in San Francisco. The Realty Syndicate paid for provisions, blankets, and tents for those needing shelter in the disaster's immediate aftermath. The park's function, as a destination for amusements and roller coaster rides, had to be suspended for a time but resumed again a year or so later.

Author Jack London's two daughters, Becky and Joan, like the young ladies pictured here, loved coming to Idora Park with their father. London's daughters lived with their mother, Jack's first wife, in a modest, brown-shingle bungalow on Forty-first Street off the Telegraph Avenue streetcar line, a mile or so from the park. His excursions with them were highly anticipated as he was so often away from them on his extended trips and adventures. Idora Park was closed in the late 1920s, and the property was later converted into a residential neighborhood.

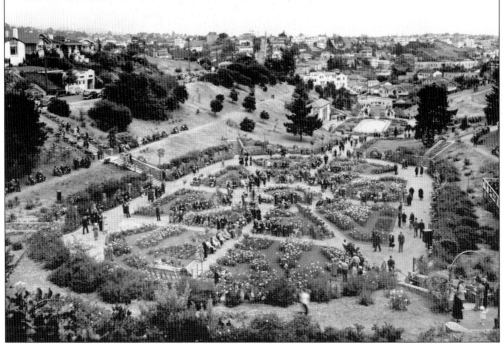

In 1911, members of the Businessmen's Garden Club, led by Dr. Charles Covell, a dentist, and Arthur Cobbledick, a landscape architect, convinced the city to purchase seven and a half acres of unused streetcar right-of-way property near the city of Piedmont in order to establish a municipal rose garden. The bowl shape arroyo, first called Linda Vista Park, offered protection from the wind, which is good for growing roses, and offered good vantage points from above for viewing the formal Florentine style rose beds with their patterns of colorful blooms. In 1933, Mayor Frank Morcom planted the garden's first rose; later the garden was officially named the Frank Morcom Rose Garden in his honor.

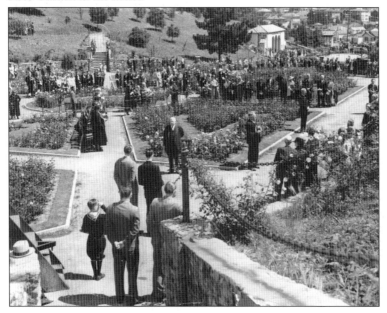

Rose Sunday in May, sponsored by the Junior Chamber of Commerce, was a popular annual event for many years. According to this 1938 photograph's caption, 5,000 were on hand to attend that year's gathering. A little boy salutes as the Municipal Band plays the National Anthem.

During the Depression, WPA workers, who created stone steps and pathways and a cascading fountain, provided labor to lay out the garden. A Mediterranean-style, loggia-viewing pavilion, also used to store tools, was another of the garden's attractive features.

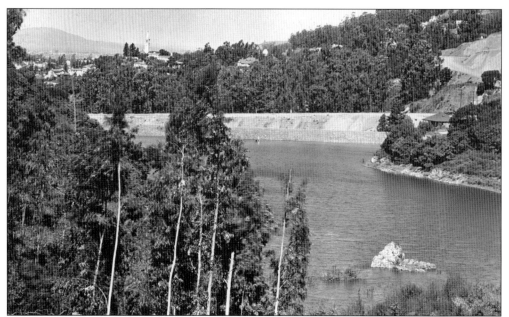

Lake Temescal (with UC Berkeley's campanile tower visible in the distance) is pictured here. In 1869, a French Canadian named Anthony Chabot (1814–1888), who was a hydraulic engineer during the gold rush, built a dam across Temescal Creek in order to create a reservoir to store drinking water for Oakland's growing population. Several decades later, in the 1930s, the former reservoir and its surroundings became part of the newly established East Bay Regional Park District.

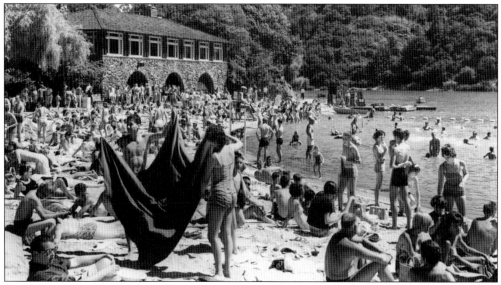

Starting in the 1920s, various citizens groups lobbied for the creation of more public open space. Former Oakland mayor (and at that time a member of the state assembly) Frank Mott introduced legislation in Sacramento to establish a regional parks district board—the first of its kind in the country—to oversee 10,000 acres of new parkland. On hot sunny days, Lake Temescal's swimming beach, pictured here c. 1950, is a popular attraction. The rustic beach house, with changing rooms, food concessions, and an upper-level view pavilion, was extensively refurbished in 2004 and is now listed on the National Register of Historic Places.

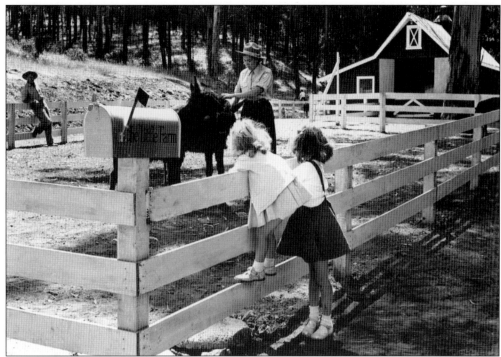

In the 1950s, the regional park system's Tilden Park in the Berkeley hills opened such children-friendly attractions as the Little Farm (above) and scale-model locomotive train rides that followed tracks laid out by dedicated volunteers, meandering through the pristine parkland (below). The park is named for local civic leader Maj. Charles Lee Tilden of Alameda, a banker and Spanish-American War veteran who would earn the title "father of the parks" for his strong advocacy and support for the district in its early years.

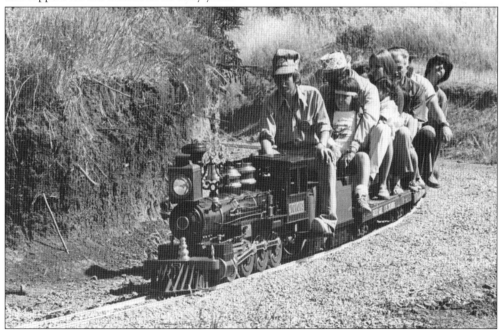

By the close of the 1990s, the park district was serving 1.5 million people and had grown to close to 80,000 acres with parcels throughout the two counties. It was comprised of 13 regional parks, 8 regional preserves, 9 recreational areas, 14 regional shorelines, and hundreds of miles of hiking trails, making it the largest multi-county park system in the country.

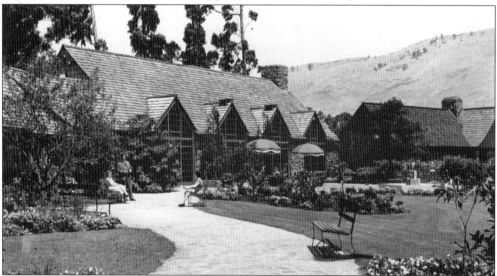

Also located in Tilden Park is the historic Brazilian Room, a popular venue for weddings and other special occasions. The building's unique paneled interior was left over from the 1939 Treasure Island World's Fair and donated to the park district by the Brazilian government. Public Works Administration (PWA) workmen constructed the building's handsome stone exterior and surrounding terraces. New Deal agencies such as the Civilian Conservation Corps and the PWA furnished 60 percent of the salaried costs (an estimated $3 million) for the workers who would clear hiking trails, bridle paths, and fire breaks during the park district's early years. Unemployed local residents could sign up for the available park construction jobs, another added benefit.

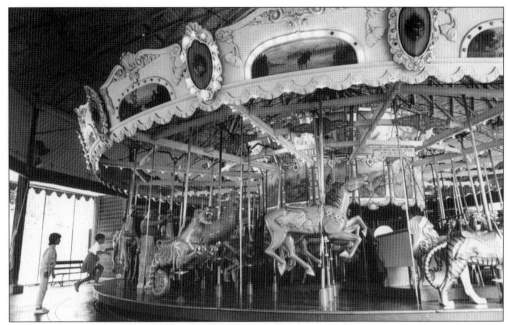

A vintage carousel built in 1911 was imported to Tilden from Southern California in the 1940s. Enjoyed by generations of families, it was painstakingly restored in recent years and is now listed on the National Register of Historic Places.

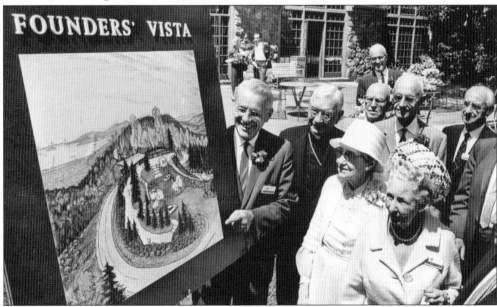

William Penn Mott Jr. (1909–1992) was general manager of the East Bay Regional Parks District for five years, from 1962 until 1967. He is pictured here in 1965 on the park district's 30th anniversary, unveiling an artist rendering for a proposed "founders' vista" overlooking the bay and the Golden Gate Bridge. Bill Mott (no relation to Mayor Frank Mott) would go on to direct the state parks system during California governor Ronald Reagan's administration in the 1970s. As president, Reagan would appoint Mott to head the National Parks Service as well. Mott has been called the most influential professional in the parks field in the last half of the 20th century.

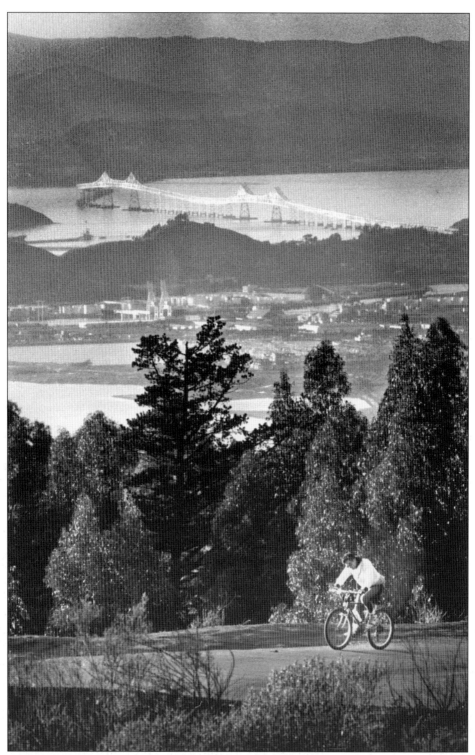

A lone cyclist rides along a trial in Tilden Park in this 1988 photograph. The Richmond Bridge is visible in the distance.

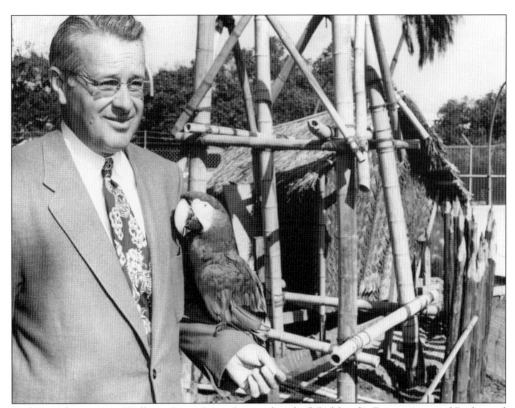

Earlier in his career, William Penn Mott Jr. was head of Oakland's Department of Parks and Recreation for 17 years. Along with local nursery owner Arthur Navlet (who had been impressed with miniature nursery rhyme–themed displays he had seen at a children's zoo in Detroit), Mott conceived of an enchanted theme area for families in Oakland's Lakeside Park called "Fairyland." Mott and Navlet approached a civic organization, the Lake Merritt Breakfast Club, for the initial $50,000 in financial backing. Mott then hired local artist William Russell Everitt to design zany quarter-size storybook "sets." Barnyard animals, Munchkin-style costumed guides, and fanciful landscaping completed the overall affect.

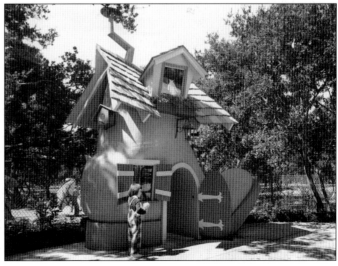

Fairyland officially opened on September 2, 1950, and charged 9¢ to 14¢ for admission, depending on the age. To go in, visitors had to stoop down and make their way through a doorway in the shoe from the "Old Woman in the Shoe" nursery rhyme.

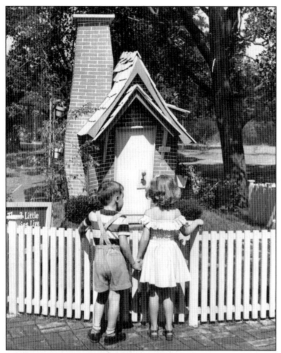

On opening day, two five-year-olds visit the brick house from "Three Little Pigs" (left), and a children's choir sings during dedication ceremonies for the Children's Chapel of Peace in December 1957.

Oakland mayor Elihu Harris accompanies "Little Red Riding Hood," and Jack from "Jack and the Beanstalk" through the park in this 1990 image.

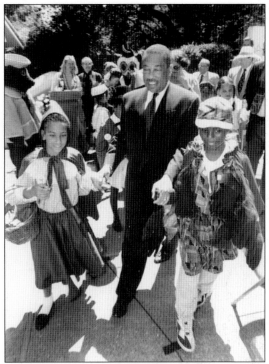

Fairyland kids in costume pose for this group portrait, taken in 1990. Walt Disney is known to have visited Fairyland shortly after it opened in 1950 to get ideas for his own theme park to open in Southern California.

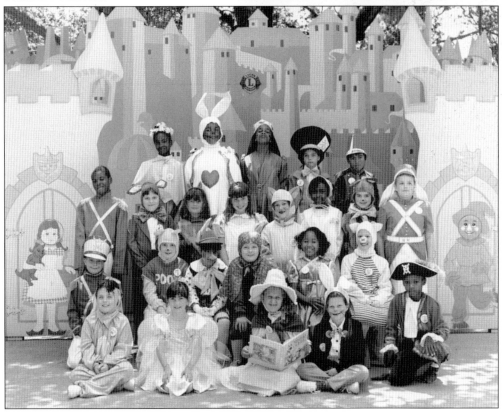

A family of Canadian geese make themselves at home in Lake Merritt's Lakeside Park in this undated photograph. The lake has the distinction of being the first officially recognized wildlife refuge in the country, so designated in 1868.

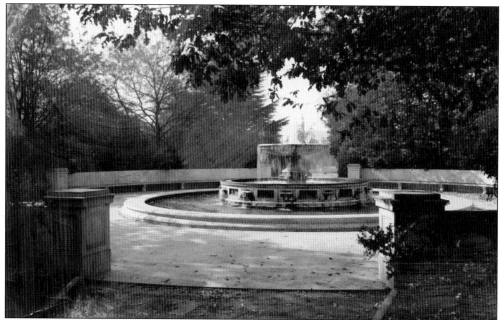

Lakeside Park's elegant McElroy Memorial Fountain dates from 1910 and honors John McElroy, Oakland's city attorney during the Mott administration who helped establish the parks department and who spearheaded the legal challenges that won back the waterfront (see chapter two).

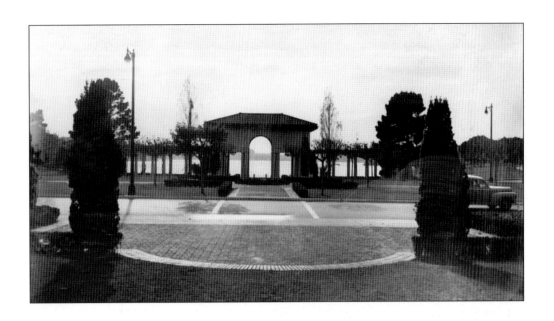

Mayor Mott's tenure (1905–1915) saw many improvements to Lake Merritt, thanks to the passage of voter-approved bonds he vigorously promoted. All of the land around the lake finally came under city ownership, boulevards circling the lake were completed, and structural amenities such as the curving pergola called El Embarcadero and the Municipal Bandstand, both designed by locally prominent architect Walter Reed, were added during this time.

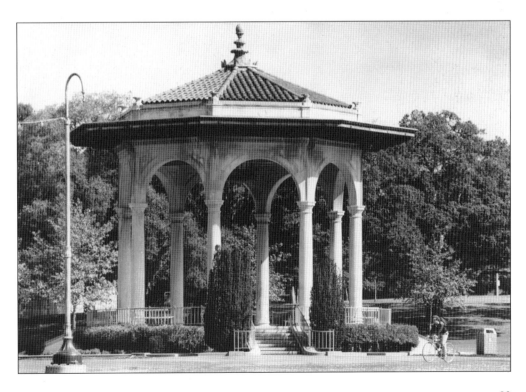

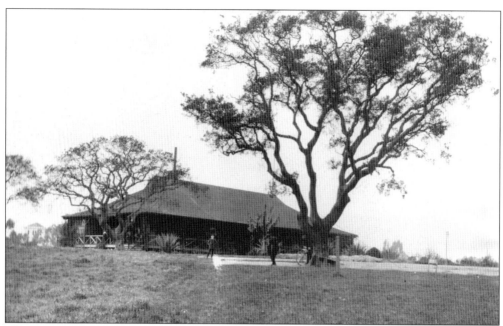

These are c. 1890 photographs of a clubhouse, which is no longer standing, overlooking what the was Oakland's first golf course. The clubhouse and course stood approximately where Fairyland is today at the Adams Point end of the lake. Adams Point, named for early town founder and land speculator Edson Adams (who some say helped to bamboozle the Peraltas out of their valuable land holdings), remained in private hands until 1910 when it was finally turned over to become a public park.

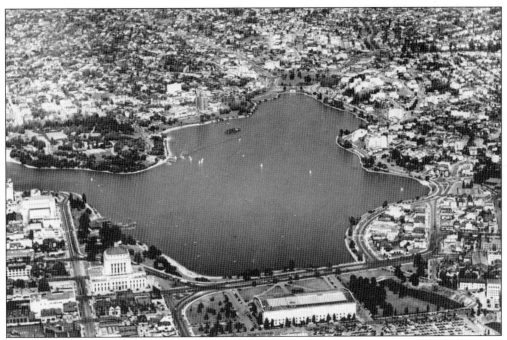

For a dozen years in the 1980s and 1990s, a three-day event in June, Festival at the Lake, drew thousands to Lakeside Park to experience food, crafts, music, and more. The state department of agriculture was the event's primary sponsor, harkening back to earlier days when county fairs sponsored by the department were an annual occurrence throughout California. Oakland's "festival" was considered unique because of its distinct urban flair.

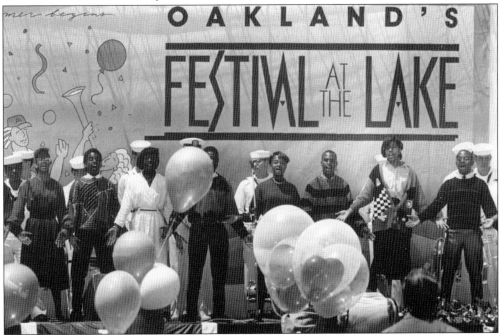

The Castlemont High School Castleers, accompanied by the U.S. Navy Band, serenade fair-goers in this 1988 photograph.

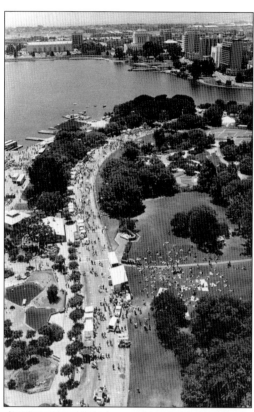

During its tenure, Festival at the Lake was the largest multicultural event in Northern California, bringing in more than 100,000 visitors and scores of musicians, artists, chefs, storytellers, and craftspeople.

Third-graders from Jefferson Year-Round School perform at the festival in this 1989 image.

As popular as Oakland's Lakeside Park can be, those seeking solitude can find that as well. This photograph was taken in 1985.

This photograph of an afternoon sail on the lake (note the Tribune Tower in the distance) was used for the newspaper's 1941 *Yearbook* publication.

Oakland residents enjoy many other parks and playgrounds located throughout the city. This is a 1962 photograph of a dragon play structure in Madison Square Park near Chinatown. When the town of Oakland was first laid out in the 1850s, it featured eight public squares. Madison Square is one of the original eight.

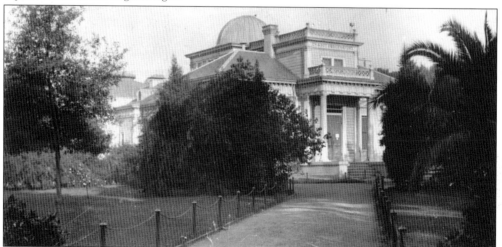

Jefferson Square, another of Oakland's original town squares, was the location for a sky observatory and telescope donated by Anthony Chabot. With the great wealth accumulated from his water-company enterprises, Chabot would become a benefactor to many worthy charities and civic enterprises. As urban development increased and with electric lights obscuring the night sky, Chabot's observatory was forced to move to the Oakland hills in the 1990s.

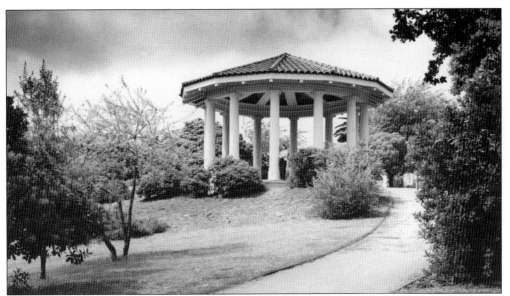

Located in San Antonio Park between Sixteenth and Eighteenth Avenues and Foothill Boulevard, this water temple-like structure was built in 1910 over a reservoir that is no longer in use. San Antonio Park is one of the oldest public open spaces in the East Bay. First known as Independence Square, it dates back to the Peralta family rancho era of the 1840s and is where bullfights, fandangos, and the occasional execution by hanging would take place.

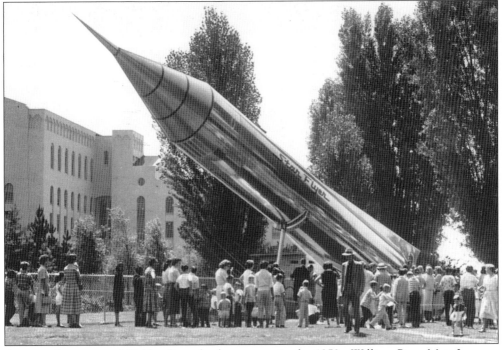

As general manager of Oakland's parks department in the 1950s, William Penn Mott Jr. came up with many ideas to attract families to city parks. Peralta Playland, along the channel where tidal waters flow in and out of Lake Merritt, featured this rocket ship attraction, called the Star Flyer, during the height of the "space race" craze.

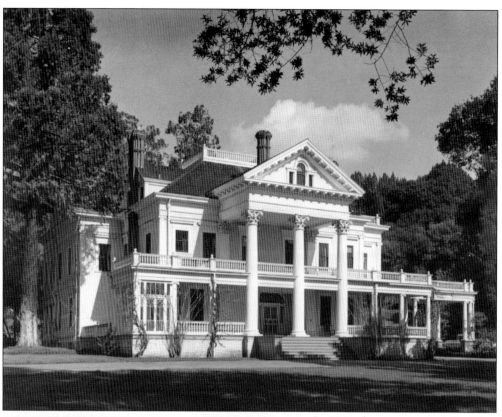

In 1961, the city acquired the 75-acre historical estate of Mrs. I. W. Hellman with grants, city funds, and state highway right-of-way funds totaling $238,000. On the secluded grounds, tucked away in the Oakland hills near the San Leandro border, stands this elegant Colonial Revival–style, 42-room mansion built in 1899, which is now carefully restored and open for public tours. Canadian-born shipping-heir magnate Alexander Dunsmuir built the home, so the story goes, as a wedding gift for his longtime mistress. The couple's time together in wedded bliss was very brief, as both died within a short time of the house's completion. Mr. Hellman, who was head of Wells Fargo Bank in San Francisco, later acquired the Dunsmuir estate, which the family then used for many years as their East Bay summer retreat.

The "Poet of the Sierras," Joaquin Miller, pictured here in his typical rustic mountain-man garb, was born Cincinnatus Hiner Miller in Indiana in 1837. He traveled overland by wagon train to Oregon's Willamette Valley with his Quaker parents as a youngster, and from there struck out on his own, roaming the gold-rush mining camps and recording his many colorful experiences for posterity. While traveling abroad in the 1870s, Miller achieved a measure of literary fame and fortune and came back to California where he settled on wind-swept hilltop property above Oakland.

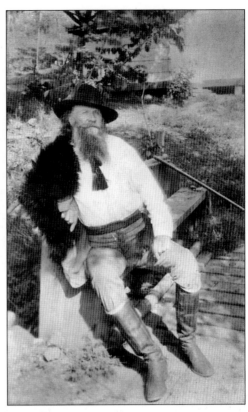

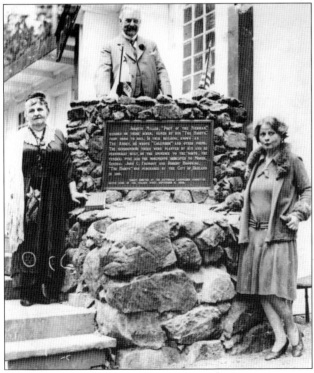

In 1919, six years after Joaquin Miller's death, his wife, Abbie, and daughter Juanita agreed to sell his estate, called the Hights, to the city for $33,000. The Native Sons of the Golden West, at the behest of the organization's landmarks chairman, *Tribune* publisher Joseph R. Knowland, erected a monument and plaque to Joaquin's memory. In this photograph, Mayor John L. Davie unveils the monument while Juanita and her mother pose, standing along side. Juanita, who devoted the rest of her life to honoring her father's memory, always found a friendly reception in Knowland's paper in the years that followed.

In the 1920s, on the hillside above Joaquin Miller's cabin (by this time verdant with the hundreds of trees the late poet had planted by hand), members of the California Writer's Club, led by its president Mrs. Gertrude Mott (wife of the former mayor), established a memorial redwood grove and water cascade dedicated to the state's writers and poets. The ongoing project continued into the 1930s, growing in scope to include an outdoor amphitheater. The stonework for the cascade steps and retaining walls was done by Public Works Administration laborers and funded by the Depression-era Roosevelt Administration. The theater would be called Woodminster.

A sun-drenched audience watches a Gilbert and Sullivan performance at Woodminster in this 1940s image.

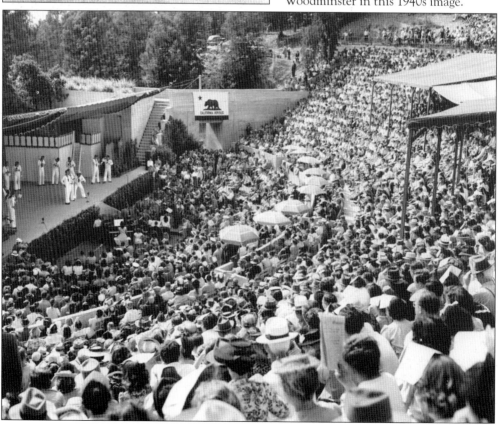

William Penn Mott Jr.'s illustrious career took another turn when he was named general manager of the East Botanical and Zoological Society, the sponsoring organization of the Oakland city zoo.

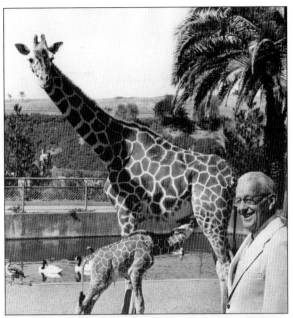

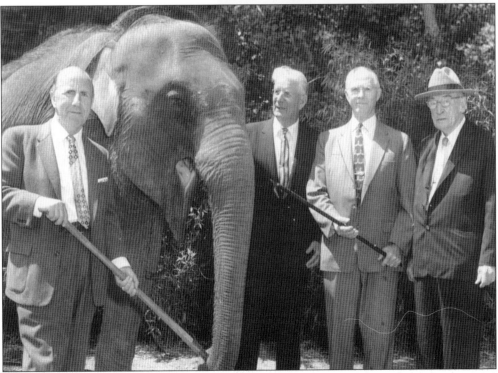

In 1958, in recognition of Joseph R. Knowland's chairmanship of the state park commission, a position he held for 23 years, the Oakland City Council officially renamed the recently acquired historic Durant estate in the East Oakland hills to Knowland State Arboretum and Park. A portion of the new park was then set aside for use as the city's zoo. J. R. is pictured here at far right with Effie the elephant. Mayor Clifford Rischell is also in the photograph, third from the right. Effie and her antics received frequent mention in the *Tribune* over the years.

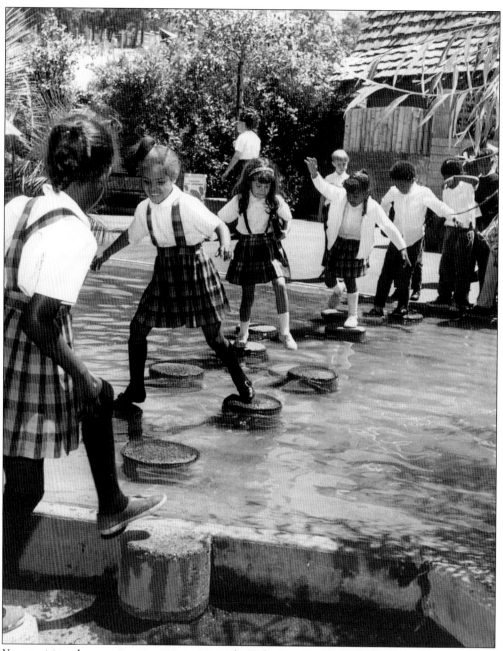
Young visitors hop across stepping-stones at the Baby Zoo in this 1970 photograph.

Five

MOVERS AND SHAKERS

Author Jack London, born on January 12, 1876, in San Francisco, grew up primarily in Oakland and the East Bay. By age 29, he was already internationally famous for *Call of the Wild*, *The Sea-Wolf*, and other literary and journalistic accomplishments. Between 1900 and 1916, he completed over 50 books, hundreds of short stories, and numerous articles on a wide range of topics. Sometimes called "the boy socialist," he articulated the aspirations and dreams of his fellow working-class comrades. He was largely self-taught, having started and stopped his formal education a number of times. Later in life, looking back, London credited encouragement he received early on from Oakland city librarian Ina Coolbrith to check out books and read as much as he possibly could.

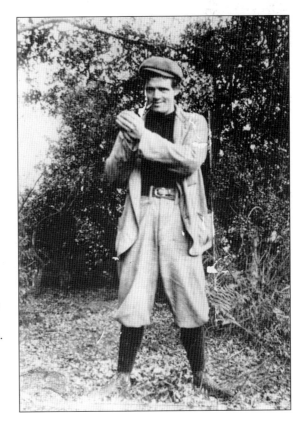

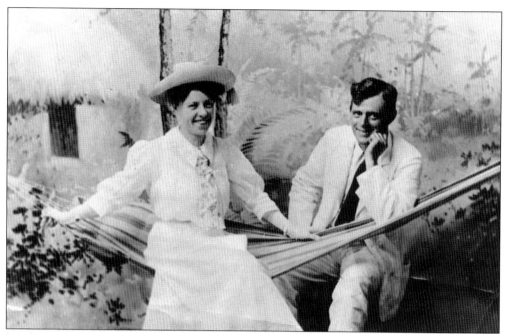

London is pictured here with his second wife, Charmian, with whom he traveled and spent time with at their "Beauty Ranch" in Sonoma County, where Jack did much of his writing. After a short but raucous life, Jack died in 1916 at the age of 40 from complications of kidney failure.

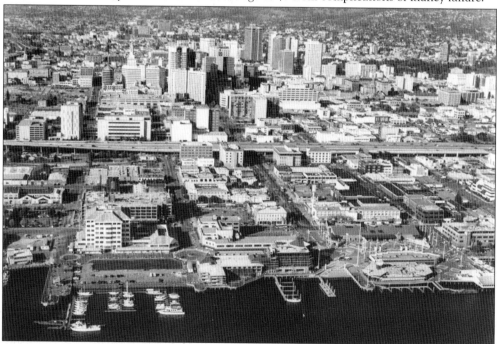

London wrote often of his youthful experiences on the rough Oakland waterfront of the 1880s and 1890s. Some 60 years later, in the early 1950s, city leaders decided to commemorate London's life and times by naming a new waterfront restaurant and entertainment district after him. Historic Jack London Square is pictured here in this aerial photograph, taken in 1990.

Jack London Square was formally dedicated on May 1, 1951, the city's 99th birthday. Parks department director William Penn Mott Jr. was asked to oversee the landscape design for the proposed district. The new Oakland destination would soon begin attracting thousands of visitors annually.

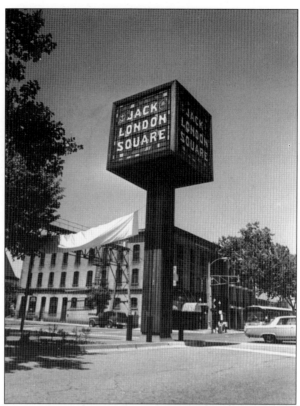

Heinold's First and Last Chance Saloon, a remnant of London's youth on the docks, still stands in its original location, which is a must-see stop on any visit to the square. Proprietor Johnny Heinold loaned young London the money to buy his first boat, so the story goes, and encouraged him to enroll at UC Berkeley. London studied words in Heinold's dictionary while seated at a table by the door, cramming to pass the university entrance exam.

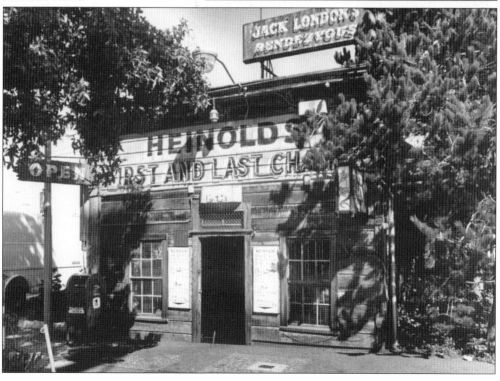

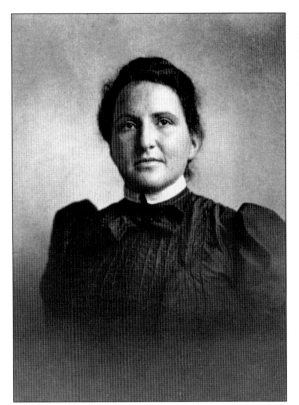

Another internationally acclaimed writer, Gertrude Stein (1874–1946), pictured at left as a young woman and as a child below, could also be said to have been shaped by her early experiences growing up in Oakland. Parents Daniel Stein and Amelia Keyser, both of German-Jewish descent, arrived in Oakland from the East Coast with their five children (Gertrude was the youngest) in 1880.

The Steins took up residence in the luxurious 200-room Tubbs Hotel just east of Lake Merritt. Mr. Stein commuted by streetcar and ferry to San Francisco. Later the family would live in a comfortable home on the corner of East Twenty-fifth Street and Thirteenth Avenue, surrounded by gardens and fruit trees.

After the death of her parents, Stein left Oakland, attended college in the east, and then traveled abroad to take up the bohemian-arts expatriate life in Paris. Soon her poems, essays, and novels achieved fame in literary circles. Many years later, on a visit back to California, she reportedly could find little left in her hometown that reminded her of her childhood, prompting her to say of Oakland, "there is no there there."

STANLEY WAS THere!

Unfortunately Gertrude Stein's often repeated and infamous quote would become something proud Oaklanders would be forced to live with. Then in 1988, local artist Roselyn Mazzilli was commissioned to create a fanciful downtown fountain centerpiece, pictured here, called *There*, seemingly putting an end to the debate once and for all.

Julia Morgan (1872–1957) grew up in Oakland, not far from the home of George Pardee. She rode the streetcar to attend classes at UC Berkeley where she studied engineering. One of her college instructors, Bernard Maybeck (see next page), encouraged her to apply to the elite Ecole de Beaux Arts in Paris, even though women were not then admitted. With persistence, Morgan broke through that barrier and received her architectural training along with the other promising students of that period. Returning to her home in the Bay Area, she established her own practice (becoming the first female licensed architect in California) and went on to have a successful and prolific career.

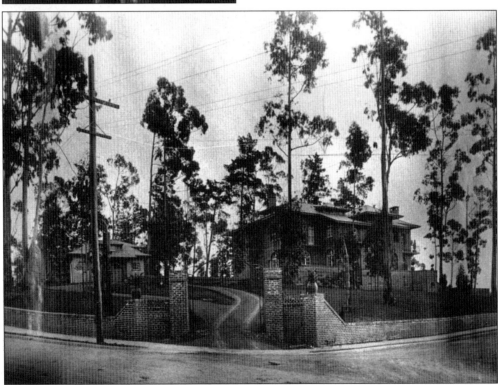

Morgan designed many gracious residences for clients in San Francisco, Berkeley, Oakland, and Alameda. Unfortunately this house on Manchester Drive in Oakland, known as "Red Gate," was lost in the disastrous 1991 Oakland Hills fire that claimed 3,000 homes and 25 lives.

The Chapel of the Chimes columbarium and mausoleum on Piedmont Avenue is a designated city landmark and one of Julia Morgan's more unusual creations. It combines a mixture of Gothic, Romanesque, and Mediterranean decorative motifs also found in Morgan's famous Hearst Castle in San Simeon, reflecting her love of eclectic styles. Chapel of the Chimes is open regularly for public tours and programs.

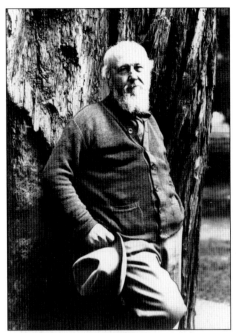

Bernard Maybeck (1862–1957) is credited with launching the so-called "Bay Area Tradition" in architecture. Born and raised in Greenwich Village, New York, Maybeck studied at the Ecole de Beaux Arts in Paris (where his future pupil and protégé, Julia Morgan, would follow in his footsteps) before coming to California in the early 1890s. He worked as a draftsman in the office of influential architect A. Page Brown and eventually struck out on his own, carrying out 200-plus projects during the course of his 30-year career. Perhaps his most famous surviving work is the Palace of Fine Arts in San Francisco.

Maybeck's best-known Oakland building might be this exotic and picturesque automobile showroom, described as "Moorish" by contemporary commentators in 1927. It was located on Harrison Street across from Lake Merritt and was torn down in the 1970s, much to the dismay of preservationists, to make way for a parking lot (see chapter six).

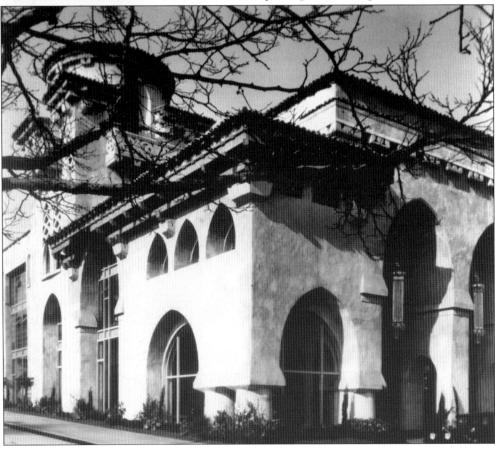

The late Calvin Simmons, born in 1950, was a childhood musical prodigy who began conducting at the age of 12. After assisting at the Los Angeles Philharmonic under Zubin Mehta, Simmons came to Oakland, where he was named the first African American conductor of a major U.S. city symphony. His brilliant career was tragically cut short in 1982 when he died in a drowning accident. The music world and the citizens of Oakland were stunned by the news.

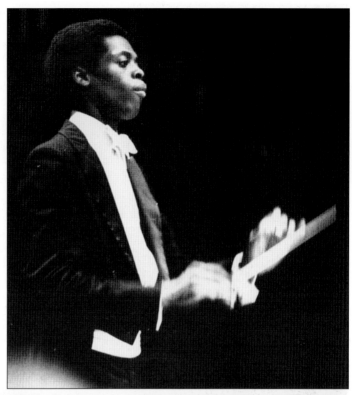

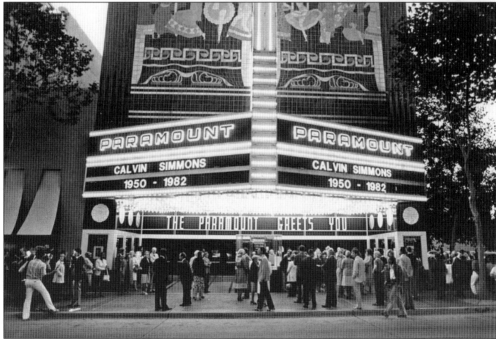

On September 20, 1982, the landmark Paramount Theatre Performing Arts Center on Broadway, which had previously been lovingly restored by the symphony association (see chapter six), held a special memorial concert in Calvin Simmons's memory.

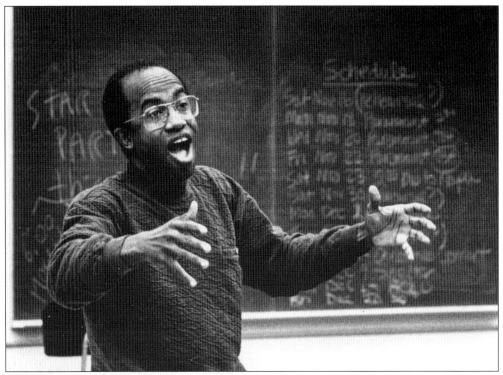

The successor to Calvin Simmons was Michael Morgan, who in 2006 is in his 16th year with the East Bay Symphony. Born in 1957, Morgan studied at the Oberlin College Conservatory of Music. Described as gregarious, bright, and innately musical, he annually makes 100 or more appearances in schools around the nation and is regarded as an expert on the importance of arts education and minority access to the arts.

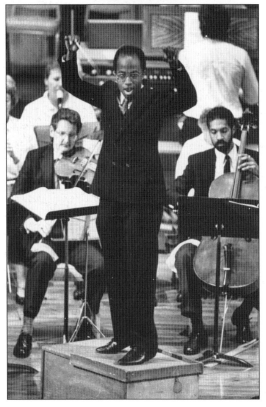

Oakland's first African American mayor was Lionel Wilson, born in 1915 in New Orleans, the eldest of eight children. The family came to Oakland when Lionel was four so his father could work in the shipyards. The first in his family to attend college, he received his degree from UC Berkeley and then attended Hastings Law School, after serving in the military oversees. Wilson was appointed to the municipal court bench in 1960 by Gov. Edmund G. "Pat" Brown and became active in local politics as a member of the NAACP. He is pictured here (on the left) in 1977 with Gov. Jerry Brown (Pat Brown's son), who followed in his father's footsteps and was elected governor in 1974.

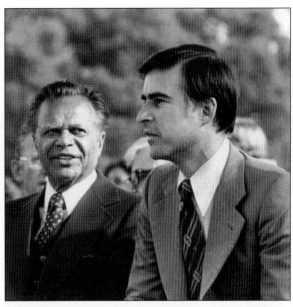

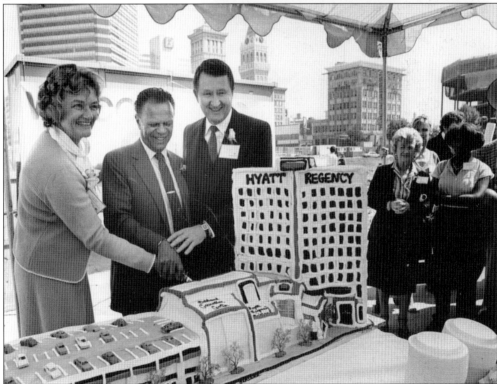

Wilson's victory at the polls was seen, state the files, as "a turning point in the history of Oakland government." During his 14-year tenure as mayor, Oakland's downtown skyline changed dramatically, with the construction of BART, new freeways, and high-rise buildings such as the new hotel and convention center complex on Broadway at Tenth Street. Mayor Wilson is pictured here, second from left, cutting a cake at the convention center groundbreaking in 1981. To his left is civic leader Emelyn Jewett, a granddaughter of *Tribune* publisher J. R. Knowland.

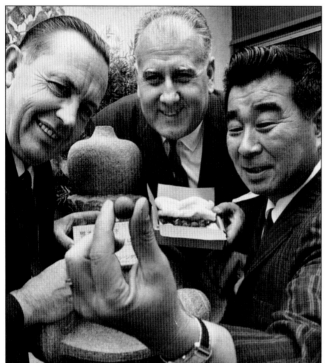

Frank H. Ogawa served on Oakland's city council for 28 years. He was the first Japanese American to be elected to a major U.S. city's governing body. Prior to coming on the council, Ogawa was chairman of the parks commission and participated in helping to establish the zoo in Knowland Park. He was also very active with Oakland's sister cities program. Along with his family, he was forced to go to the internment camps during the war years. Back in Oakland, he worked hard to reestablish the nursery business he had once owned before the war. In the top photograph, Ogawa is holding a camellia seed, a gift from sister city Fukuoka, Japan.

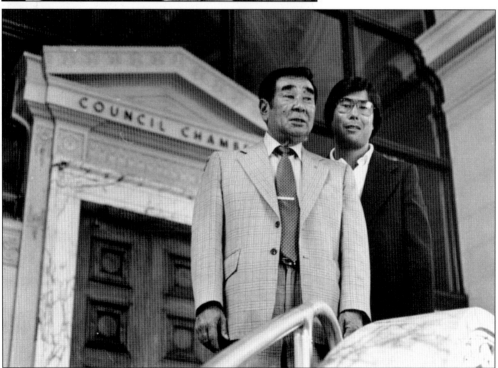

In this image, Frank Ogawa stands outside of the council chambers with his son Allen. His fellow council members voted to rededicate the city hall plaza in his honor, after his death at age 77 in 1994.

Henry Gardner, Oakland's first black city manager when he started in 1981, was also at 36 the youngest to hold that post. He guided city government for the next 12 years. Gardner's true test came in 1989 when the Loma Prieta earthquake struck, killing 66 people (42 in Oakland). Gardner and his staff were forced to evacuate their city hall offices because of structural damage to the building. He is pictured here looking across to the closed city hall from rented offices across the street.

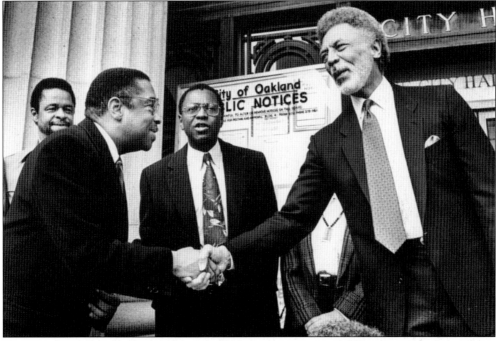

For several months, the landmark city hall's fate was uncertain. Millions were needed to fix it, and the city of Oakland did not have the money. Through the efforts of then congressman Ron Dellums (mayor in 2007), the needed FEMA funds were secured from Washington so that work could begin. Henry Gardner is pictured in the center, with Dellums at right shaking hands with Mayor Elihu Harris. After a complete retrofit (using high-tech base isolators installed in the basement) and building renovations from top to bottom—at a cost of $80 million—Oakland's city hall reopened in the fall of 1995.

Robert Maynard (1937–1993) became the editor of the *Oakland Tribune* in 1979. In 1983, through a management-leveraged buyout, he was able to assume ownership, becoming the first African American publisher of a major metropolitan newspaper. Born and raised in Brooklyn, New York, and the son of an immigrant from Barbados, Maynard dropped out of high school at 16 and, also like Jack London, read extensively on many subjects, becoming largely self-taught as a result. Maynard headed to New York's Greenwich Village in the 1950s and pursued a writing career, mingling with the other artists and avant-garde commentators of the time. In the 1980s, he moved to Washington, D.C., and started a syndicated column, carried by numerous papers across the country. He appeared regularly on television's *This Week with David Brinkley* and *The MacNeil/ Lehrer NewsHour.*

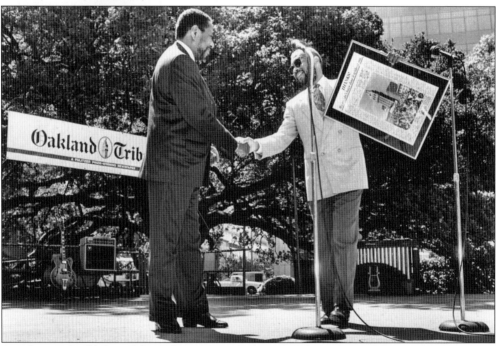

As editor and publisher of the *Tribune*, Mayard, along with his wife and fellow journalist, Nancy Hicks, steered the paper through one of the most tumultuous decades in Oakland's history. He won a Pulitzer Prize for coverage of the 1989 Loma Prieta earthquake, which was followed soon after by the disastrous 1991 Oakland hills fire. Financial difficulties would continue to hamper the paper's viability during the Maynard years, due in part to a recession brought on by the Bay Area's twin disasters. In this photograph, Robert Maynard (left) is being congratulated by Mayor Elihu Harris following a community pledge drive to keep the paper afloat.

Robert Maynard was diagnosed with prostate cancer and put up a valiant fight against the disease for a time. His ill health caused his family to make the decision to sell the paper and its assets. He died in August 1993 at the age of 56. His legacy lives on, however, with the Robert C. Maynard Institute for Journalism Education established in his memory. The institute recruits and trains minority journalism students, offering programs and initiatives to assure that diversity exists in newsrooms and television stations around the country. More than 700 graduates have participated in the institute's programs since its inception.

In the 1970s, that John B. Williams, pictured here, a redevelopment specialist from Cleveland, was recruited to Oakland to oversee numerous projects throughout the city, including rehabilitating substandard housing in West Oakland and constructing the Laney Community College campus near Lake Merritt. Several square blocks between Tenth and Fourteenth Streets west of Broadway would also be leveled during to make way for the much anticipated City Center development project city leaders envisioned would revitalize downtown.

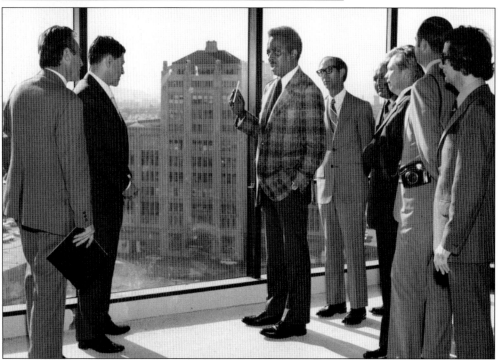

In this 1973 photograph, Williams explains to a visiting Russian delegation how the baronial Athens Athletic Club, visible through the window, will soon be reduced to rubble to make way for new development. Williams, like Maynard, would also fall ill in the midst of a brilliant career, succumbing to cancer in 1976 at age 59.

Six

LANDMARKS LOST AND LANDMARKS SAVED

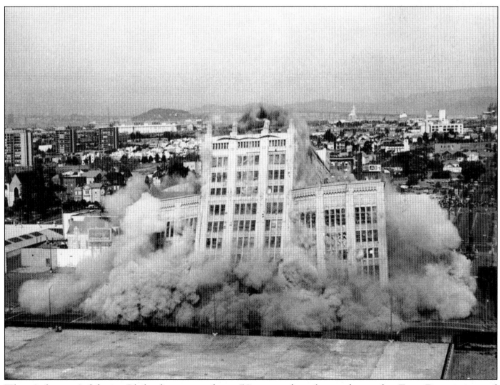

The Athens Athletic Club, for more than 50 years the place where the East Bay civic and business elite devoted time for exercise, relaxation, and fellowship, disintegrates in a cloud of dust on April 24, 1977.

The towering Gothic Revival–style Athens Athletic Club was designed by locally prominent architect William F. Knowles and stood on Clay Street between Twelfth and Thirteenth Streets. The club's grand opening was in 1925. Joseph R. Knowland was one of its founding directors.

This is an interior view of the main lounge of the Athens Athletic Club in a photograph shot for the *Tribune Yearbook* of 1932.

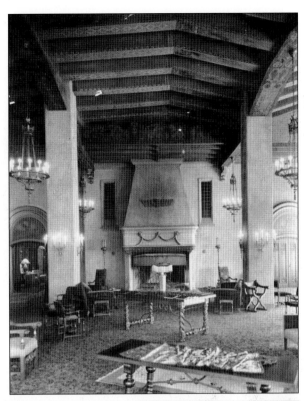

Trucks clear away the last of the rubble. The Oakland City Hall clock tower is visible a few blocks to the north.

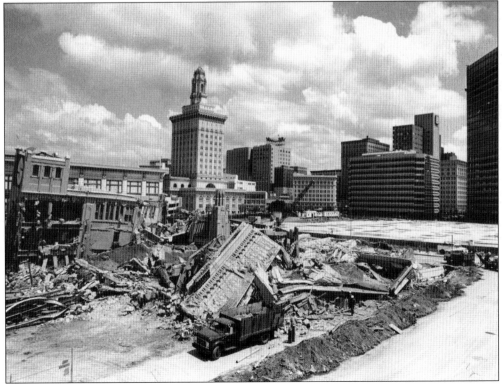

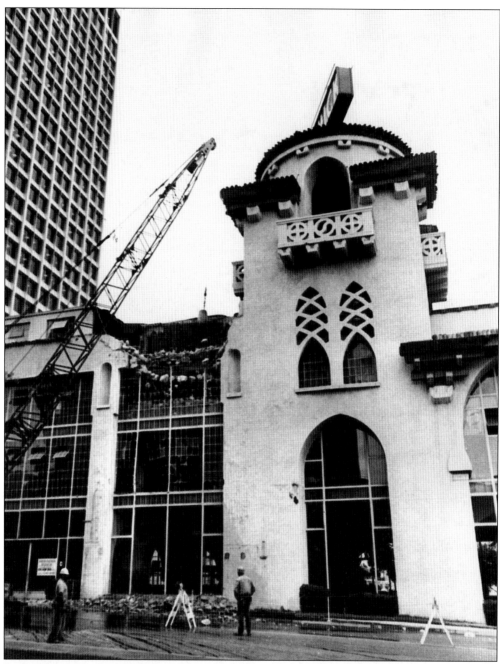

In October 1973, the Maybeck showroom building (see chapter five) came under the wrecking ball. Responding to angry citizen calls for a landmark protection ordinance, city council did vote to establish a Landmarks Preservation Advisory Board. Unfortunately the vote came too late to save the Maybeck Building.

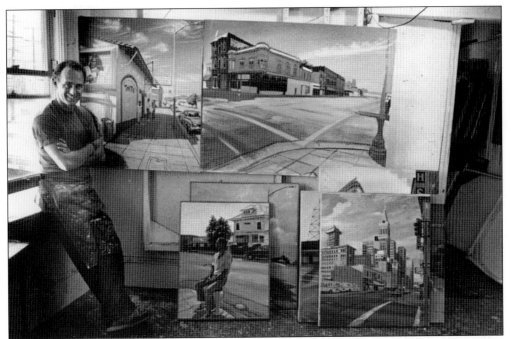

Local artist Anthony Holdsworth has been chronicling the fate of various older Oakland downtown buildings and districts for the past several years.

This is a photograph of a painting by Holdsworth depicting the earthquake-damaged Roman Catholic St. Francis de Sales Cathedral on San Pablo Avenue prior to being demolished.

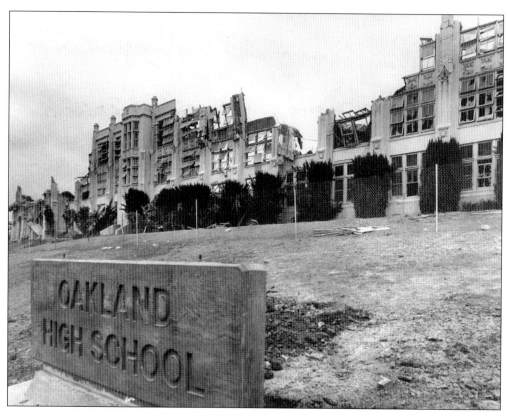

Oakland High School's date with the wrecking ball, pictured above, came on September 26, 1980, while Westlake Junior High (below) was flattened on September 24, 1975.

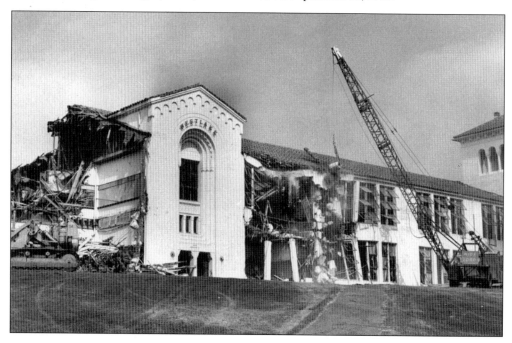

In November 1986, then congressman Ron Dellums (left) visits Oakland Technical High School to help celebrate the school's successful listing on the state historic register. The Oakland School Board had previously voted to allocate funds to rehabilitate Tech, so it was able to escape demolition. As a senior class project that year, students researched the school's history and architectural significance, and then documented the information for the landmark application.

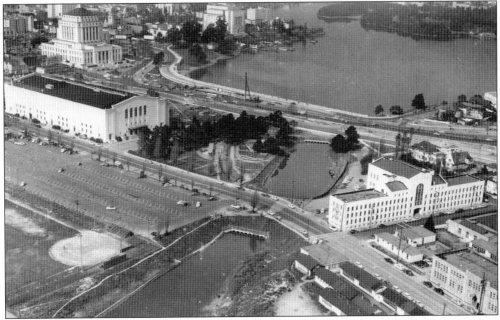

This undated photograph is of the Municipal Auditorium, which was originally built in 1914 and went under major renovation in the early 1980s. The Laney College campus next to it has not yet been built and Lake Merritt Channel Park also still awaits improvements. The large building at right is the Oakland Unified School District Administration Building.

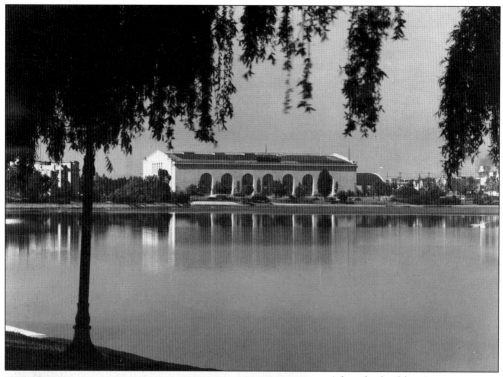

After the building's renovations were complete, the city council voted to give the auditorium a new name and it was henceforth called the Henry J. Kaiser Convention Center in tribute to the internationally famous industrialist who called Oakland home. In the image below, a Grateful Dead concert is about to get underway in the auditorium arena.

The Fox Oakland Theater on Telegraph Avenue is one of the final two surviving grand movie palaces in the Bay Area. Opened in 1929, the 76,100-square-foot theater had seating for 3,200. The firm Weeks and Day, along with builder Maury Diggs, is credited with coming up with the "Baghdadian behemoth," with its eclectic mixture of Indian, Moorish, and art deco motifs. The theater closed down in the 1960s, was put on the auction block with the expectation that it would be pulled down to make way for a parking lot, and then rescued by a local husband and wife who had fond memories of going to the movies there during their long-ago courtship days. Although closed for more than half of its life, there is hope that one day the Fox will shine again due to the ongoing concerted efforts of local preservationists and the City of Oakland, which since 1996 has been the owner of the historic landmark.

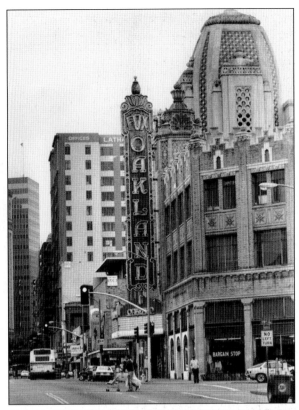

Old-time movie-theater buff Peter Botto, pictured here in 1977, signed on for what turned out to be 20-plus years of managing the historic Oakland Paramount Theater on Broadway. The Paramount first opened in 1931, two years after the Fox, which is located two blocks away. In the 1970s, the theater (by then run down) was acquired by the Oakland East Bay Symphony Association, which subsequently mounted a high-flying fund-raising campaign, heavily publicized in the *Oakland Tribune*, to raise the funds to restore it back to its art deco glory.

Gov. Ronald Reagan hands over a buck to Paramount restoration fund-raising chair Herbert Funk of the Oakland Rotary. Over $1 million would ultimately be raised to carry out the building's restoration. The Paramount's successful rehabilitation served as a model for other vintage theaters elsewhere around the country looking to achieve new lives as downtown performing-arts centers.

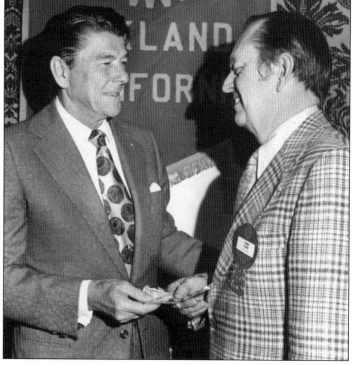

These are two interior views of the landmark movie palaces, the Oakland Fox and the Paramount. A life-sized, Hindu-inspired deity figure enthroned next to the stage stands guard in the Fox (above), and the Paramount's unique art deco–style aluminum grill chandeliers hover over the seats (below). Craftsmen familiar with the lost arts associated with vintage theater decor were recruited to carry out the painstaking restoration work.

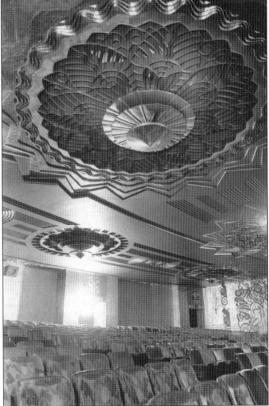

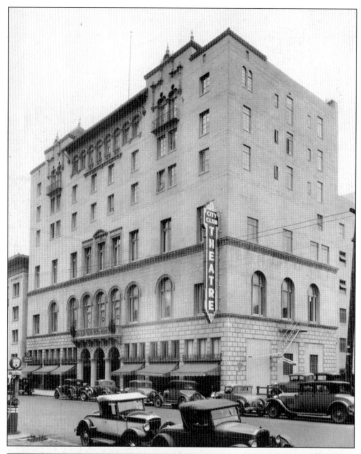

A women's club building on Alice Street from the 1920s was acquired by the City of Oakland in the 1980s to be converted into a community arts and dance center. Patty Hirota and Pauline Follansbee of Citycentre Dance Theatre are pictured below in 1992, excited about their newly renovated rehearsal space. Known initially as the Alice Arts Center, the facility was renamed the Malonga Casquelourd Center for the Arts in honor of the late Malonga Casquelourd (1947–2003), a highly respected dancer and drum master who often held classes and performed there.

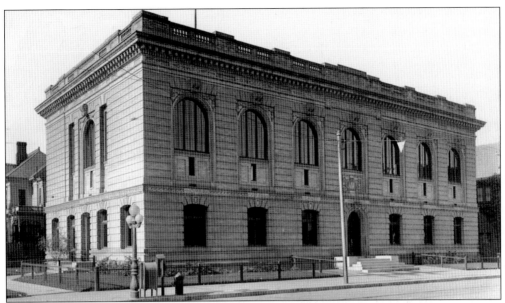

The Charles Greene Library on Fourteenth Street was Oakland's Main Library in the early 1900s. Greene, who was head librarian at that time, approached the Andrew Carnegie Foundation for the funds to build the facility. Oakland eventually would receive enough money from the foundation to open the Main and four other branch libraries as well. Due to the city's population growth after 1906, the old Main soon became obsolete. By the 1980s, it was regarded as a stately yet aging "white elephant." Fortunately a new use would be found when it became a permanent repository for East Bay African American heritage and culture. It is now called the African American Museum and Library of Oakland.

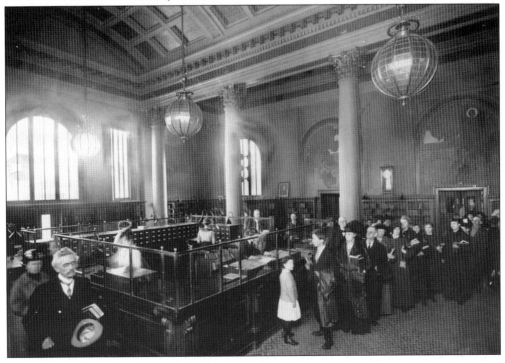

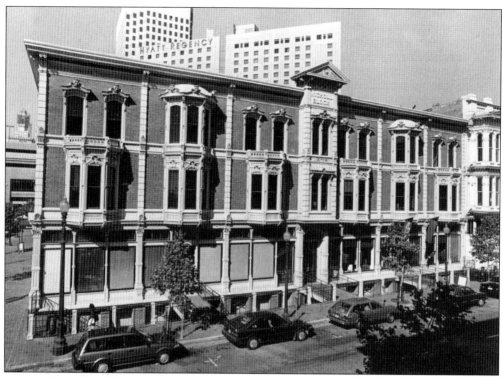

During downtown Oakland's redevelopment in the 1970s and 1980s, not every historic building was lost. A block along Ninth Street between Washington Street and Broadway, called "Victorian Row," was carefully rehabilitated and restored by partners (and brothers) Glen and Richard Storek in cooperation with the City's redevelopment agency. This image is of the 1878 Nicholl Block Building. Also visible in this 1990 photograph is the newly completed Hyatt Regency Hotel and Convention Center a block to the north, providing quite a contrast between Oakland's 19th- and 20th-century downtowns.

This is a close-up view of one of the unusual gargoyle figures (thought to ward off bad luck some have speculated) found above each of the third-story windows of the Nicholl Block Building. In the early days of the *Oakland Tribune*, the newspaper rented a small office on this block of Ninth Street when it was the heart of the growing city's downtown.

124

This is an image taken before restoration work on the Italianate-style commercial structure began. The Storeks would spend more than 14 years completing the project.

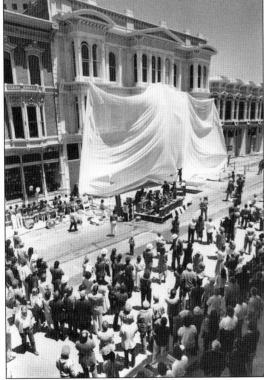

Crowds gather to "oohh and ahhh," states this caption for a photograph of the restoration unveiling that ran in the newspaper on Thursday, May 29, 1986.

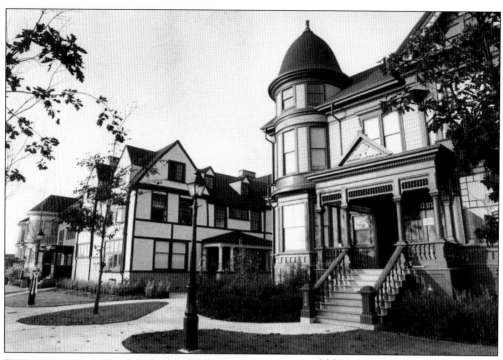

Old Victorians, clustered between the 980 Freeway and downtown, also survived the urban renewal years, and they too would undergo a careful renovation, emerging in the late 1980s as Preservation Park. Pictured at left, in 1986, are workers finishing new street improvements with the installation of vintage-looking street lamps. The intention was to replicate a typical Oakland Victorian-era residential neighborhood from the late 19th century. A master plan developed by the redevelopment agency called for having the houses, once finished, converted into offices for nonprofit organizations along with rental facilities for workshops, seminars, and receptions. The Robert C. Maynard Institute (see chapter five) is currently a tenant in Preservation Park.

Altogether there are 16 houses in Preservation Park. Some of them, including the Hunt House (right), were rescued and moved to the park from the path of the nearby 980 Freeway. The various Victorian styles are represented, including Queen Anne, Italianate, and Colonial Revival. Even the fountain (below) was moved from another location. The Latham Fountain's cast-iron female figure is the goddess Diana and was fabricated in France in the late 1880s by J. H. Ducel and Sons and then shipped around Cape Horn to adorn the gracious lakeside gardens of the historic Latham family estate. Many years later, the Lathams' home was demolished to make way for new development, but luckily the fountain was saved and has ended up the centerpiece of the park.

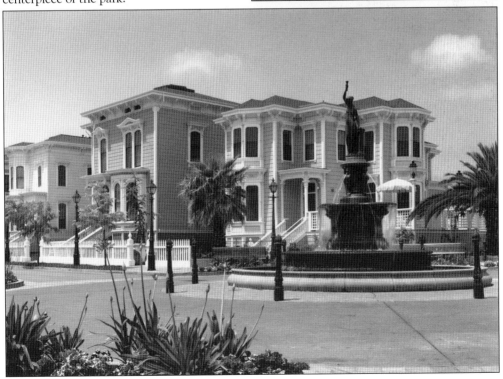

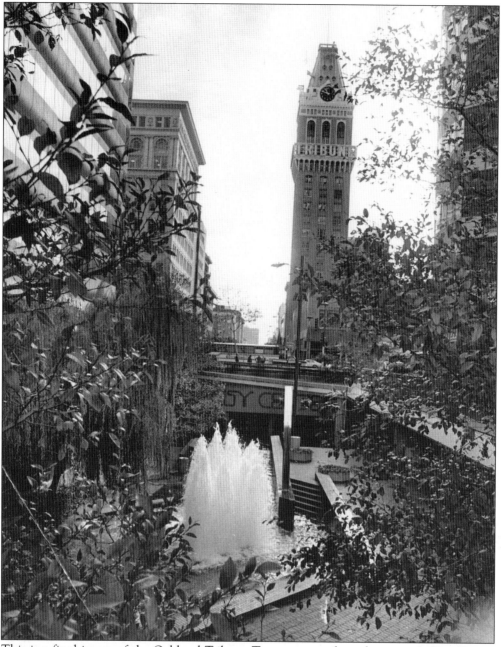

This is a final image of the Oakland Tribune Tower as seen from downtown's City Center
c. 2000..